19.95

America THE Beautiful
CONNECTICUT

JORDAN WOREK

Photographs by JACK McCONNELL

FIREFLY BOOKS

A FIREFLY BOOK

Published by Firefly Books Ltd. 2011

First printing

Publisher Cataloging-in-Publication Data (U.S.)

Worek, Jordan.
 Connecticut / Jordan Worek.
[96] p. : col. photos. ; cm. America the beautiful series.
Summary: Captioned photographs showcase the natural wonders, dynamic cities,
celebrated history and array of activities of Connecticut.
ISBN-13: 978-1-55407-787-8
ISBN-10: 1-55407-787-7
1. Connecticut – Pictorial works. I. Liebman, Dan. II. Title. III. Series.
917.46044 dc22 F101.W6745 2011

Published in the United States by
Firefly Books (U.S.) Inc.
P.O. Box 1338, Ellicott Station
Buffalo, New York 14205

Published in Canada by
Firefly Books Ltd.
66 Leek Crescent
Richmond Hill, Ontario L4B 1H1

Cover and interior design: Kimberley Young

Printed in China

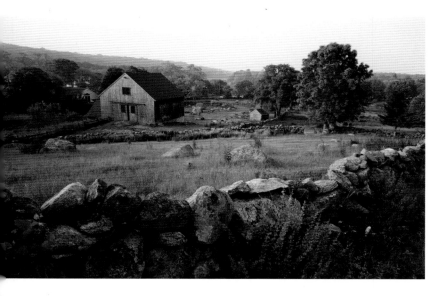

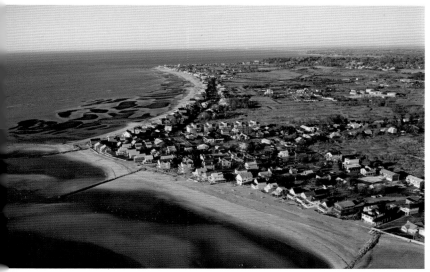

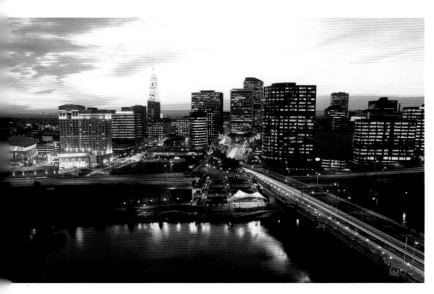

CONNECTICUT may be the third smallest state geographically, but it has the fourth highest population density, packing a lot of interesting people into some of the prettiest places in the East. Its charms may be more subtle than the soaring towers of New York City or the staggering monuments of Washington DC, but Connecticut was one of the original Thirteen Colonies — and its numerous Revolutionary War sites attest to its importance in the founding of the United States.

The first English settlers were Puritans who came to Connecticut in 1633. The state is perhaps best known today for its tidy colonial towns snugly set in the rugged but beautiful landscape. Many of these picture-postcard communities have been carefully preserved and attest to the fact that Connecticut is at the top of numerous lists — for example, it boasts the third-highest median household income in the country.

Connecticut may be famous for its white-steepled churches, clapboard houses, red barns, covered bridges and winding stone walls, but there's more than Revolutionary history, antiques and rural charm. Mystic Seaport, the world's largest maritime museum, is a great place for hands-on learning about a once-vital industry. Among many places of interest in Hartford are the State Capitol Building and the new Connecticut Science Museum. Few visits to Connecticut are complete without a stop in New Haven to see Yale University, one of the most prestigious academic institutions in the world.

For those interested in history, academia and the finer things in life, Connecticut is a dream come true. It has a thriving arts scene, cultural events and scenery beautiful enough to coax any traveler out of the car. We hope you enjoy the journey as you travel the pages of *America the Beautiful – Connecticut*.

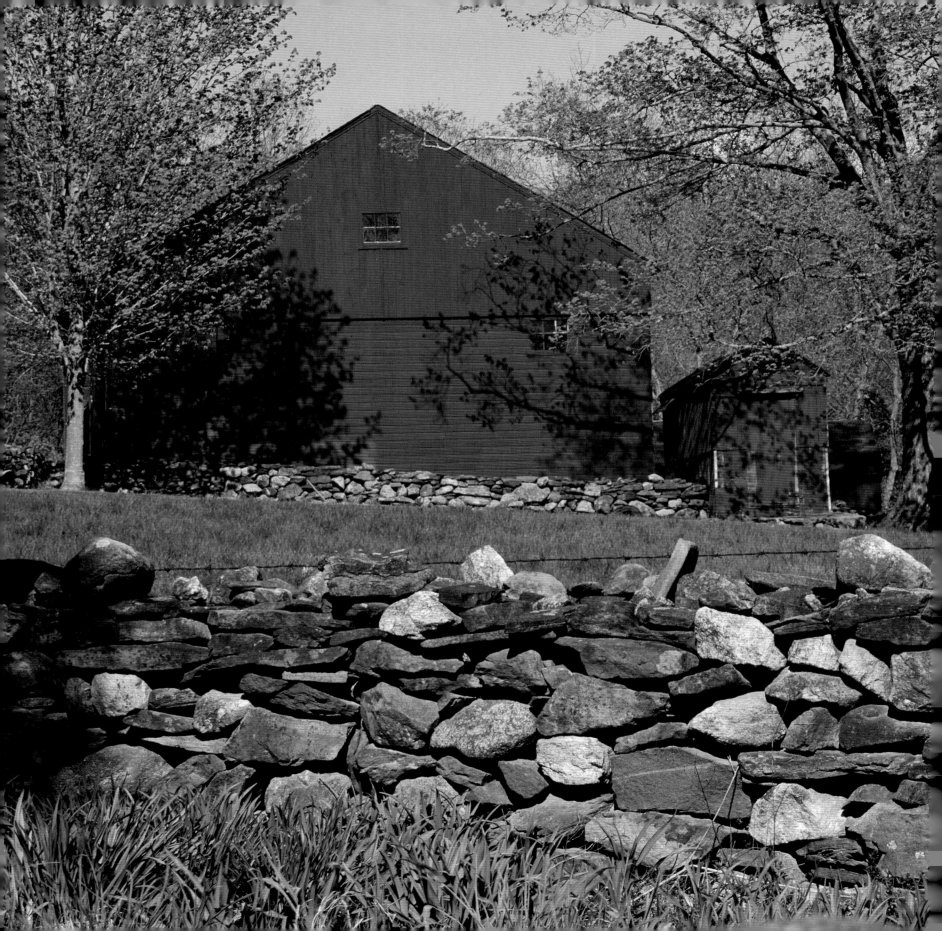

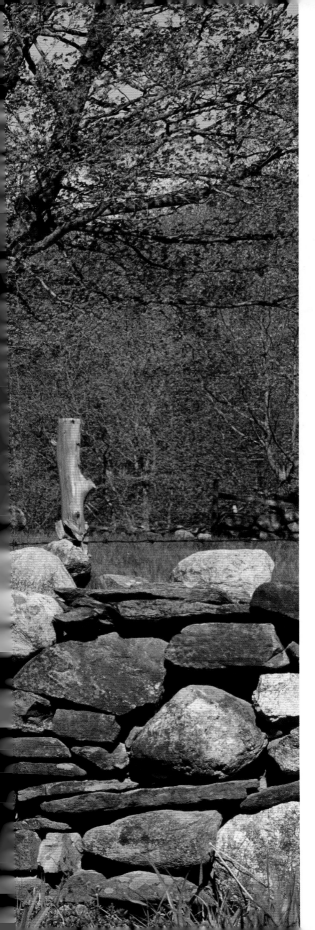

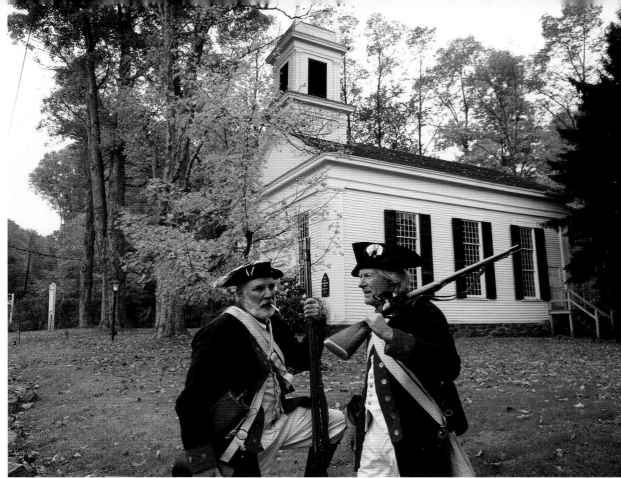

ABOVE: The Washington–Rochambeau Revolutionary Route, designated a National Historic Trail in 2009, is a series of encampments and trails used by the U.S. Continental Army under George Washington. Here in Ridgefield — and at many other places along the route — markers and historical reenactments help to make history come alive.

LEFT: Connecticut, with its white steepled churches, clapboard houses and red barns, is quintessential New England. Village greens and stone walls are other common features of the built landscape that are much loved by visitors and locals.

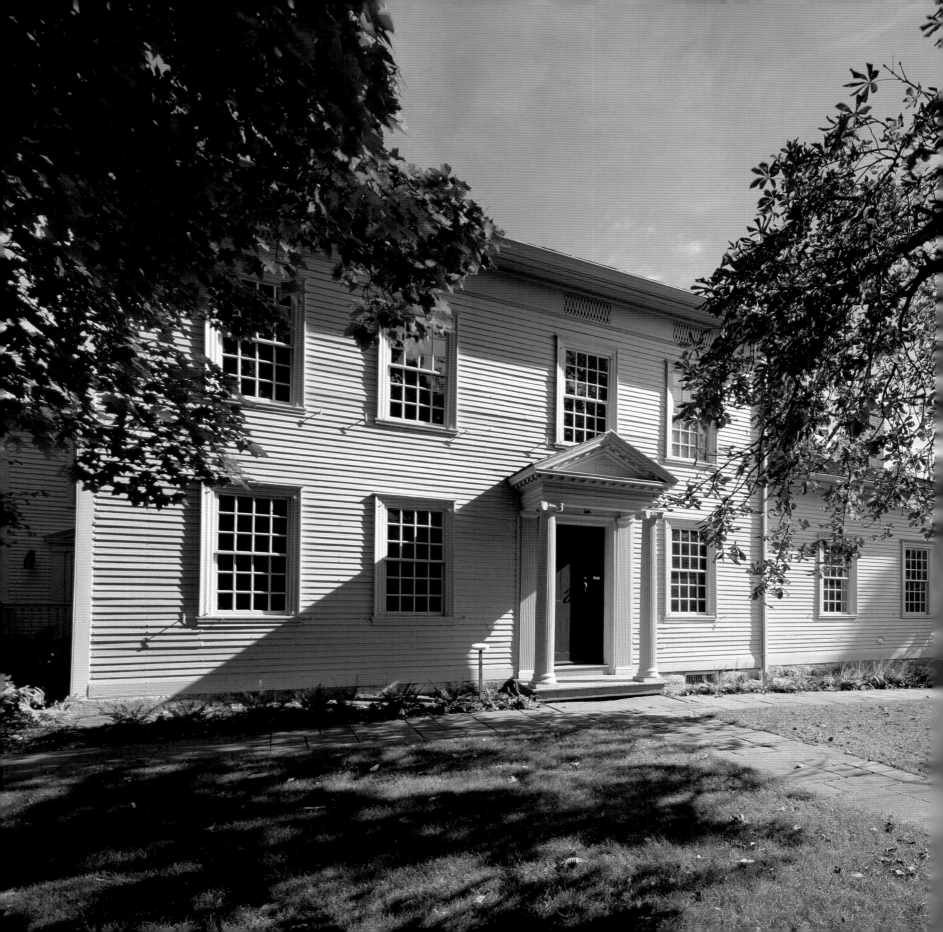

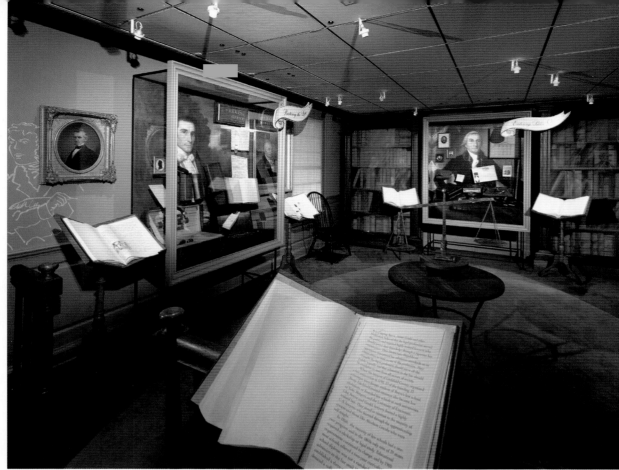

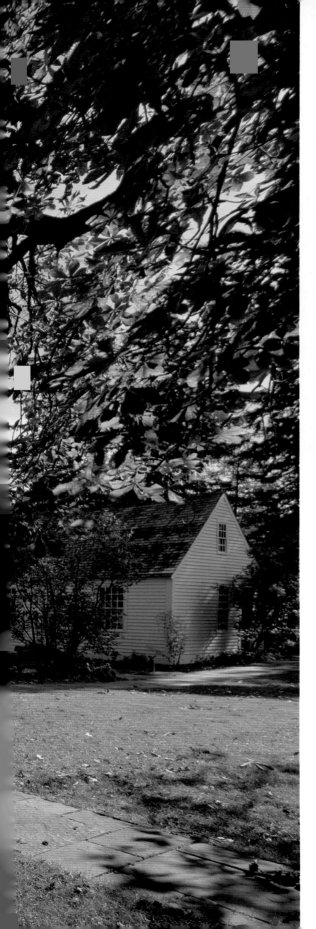

ABOVE: Visitors to Litchfield's Tapping Reeve House and Law School learn about the important contributions of Reeve and the students he taught. Two vice-presidents, more than 100 congressmen, 28 senators, three justices of the Supreme Court and 14 governors graduated from this small school.

LEFT: Established in 1773, the law school launched the careers of many of the nation's post-Revolutionary figures. The organized legal training that Reeve developed was revolutionary in a time when the apprenticeship system was the norm.

The White Memorial Conservation Center is a 4,000-acre sanctuary in the hills outside Litchfield. Established in 1964, the center grew out of the former home of Alain White, a pioneering conservationist, and his sister, May.

The conservation center offers trails, campgrounds, boating facilities and a museum concentrating on local natural history. The education-focused center is a popular destination for many local schoolchildren.

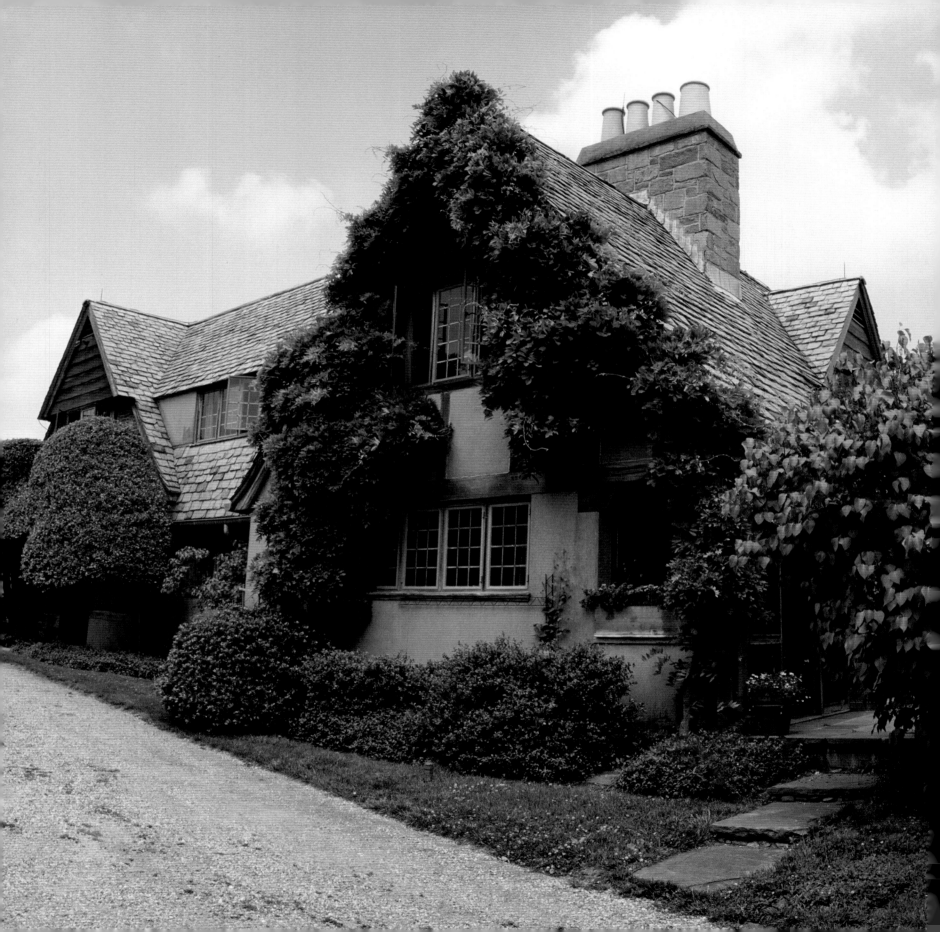

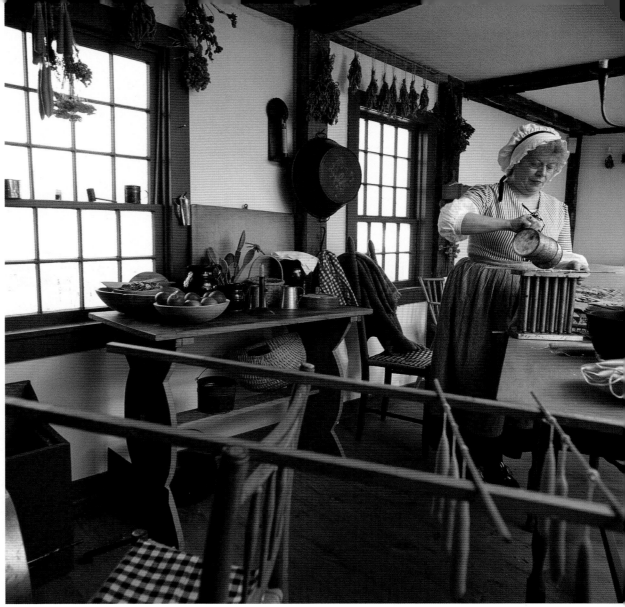

ABOVE: The Solomon Goffe House in Meriden — midway between Hartford and New Haven — was built in 1711. Today, the home serves as a working museum on life in the 18th century.

LEFT: In 1917, Edith Chase received 16 acres on Jefferson Hill from her businessman father. She originally created a simple cabin on the land. Over the years, thanks to her shrewd investments, she was able to afford to create an extensive English Tudor mansion designed by the famous architect Richard Henry Dana, Jr. On her death she left the property and its beautiful gardens, known as Topsmead, to the people of Connecticut.

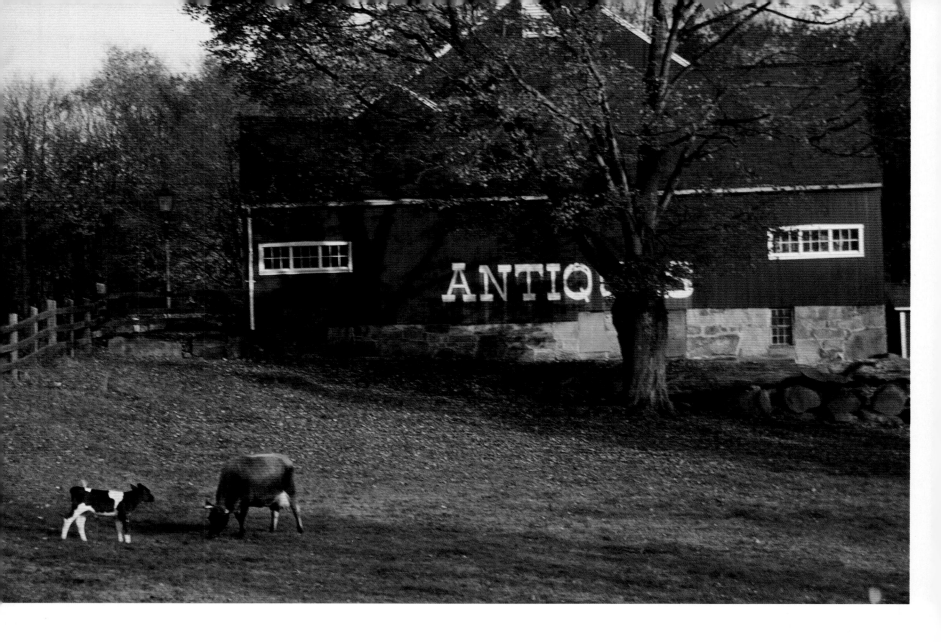

The town of Woodbury is known as the antique capital of Connecticut. With its wealth of history and countless well-preserved buildings, the state offers locals and visitors many opportunities for owning a piece of the past. Over 30 antique dealers are congregated in this one town alone.

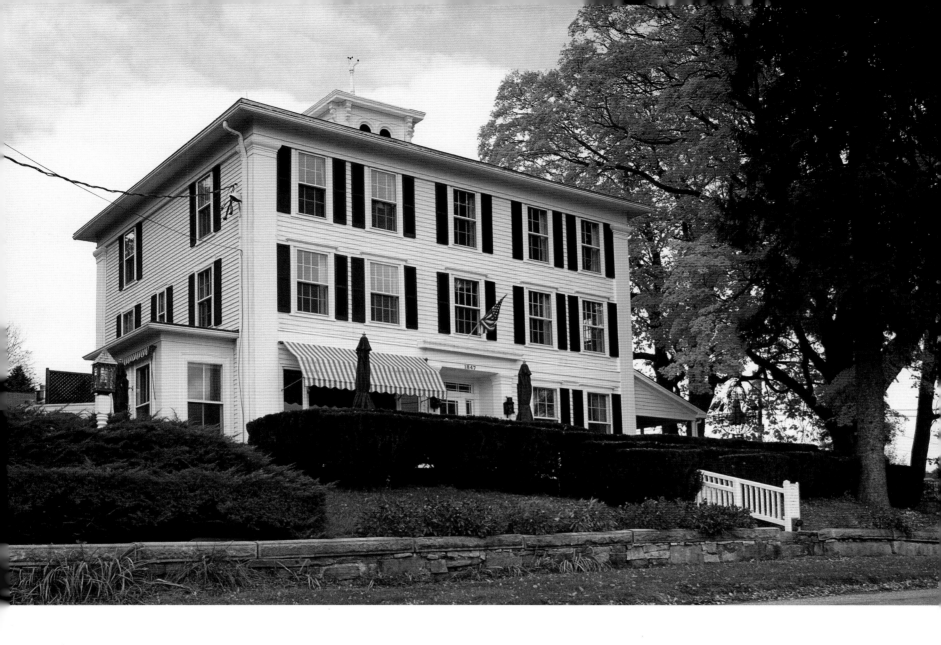

New Preston, a picturesque village in Litchfield County, was founded by colonists in 1741. The town is a popular seasonal getaway for New York residents and attracts increasing numbers of visitors. New Preston was revitalized in the 1990s and now boasts numerous restored 18th- and 19th-century buildings. The Hopkins Inn has welcomed visitors since 1847.

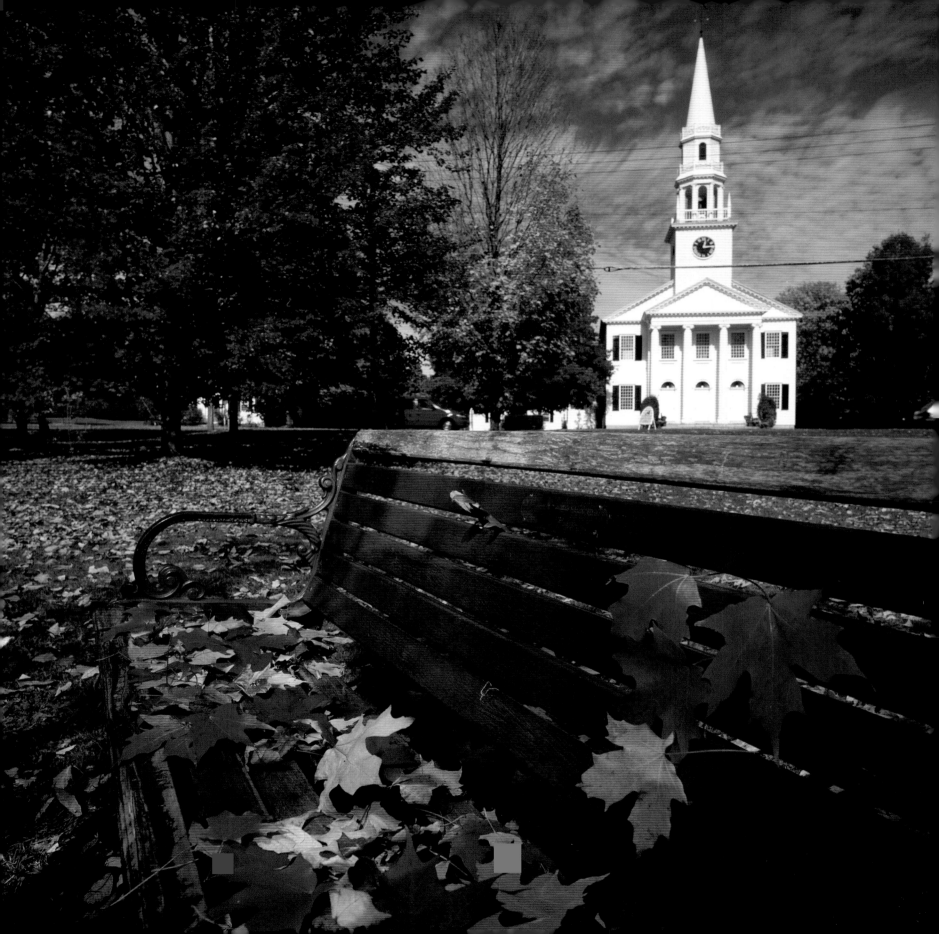

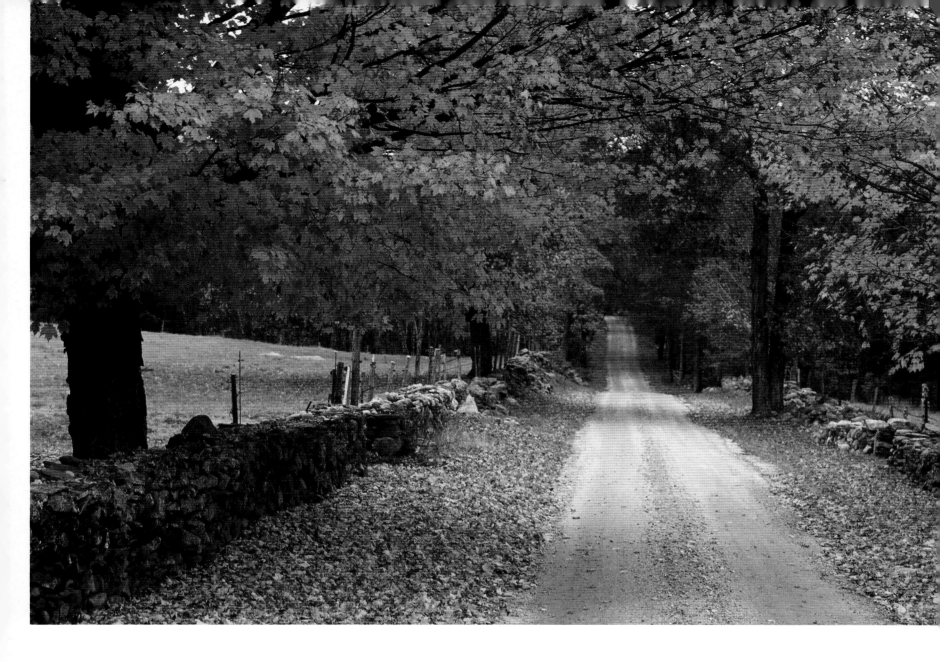

Lebanon is a small farming town in New London County, east of Hartford. The picturesque community is a wealth of 18th-century history. Lebanon was home to William Williams, a signer of the Declaration of Independence, and Governor Jonathan Trumbull, Sr.

OPPOSITE PAGE: Litchfield, founded in 1721, is located in the scenic Northwest Hills and served as a "safe town" for Continental forces, secure from British attack. It emerged unscathed from the Revolutionary War.

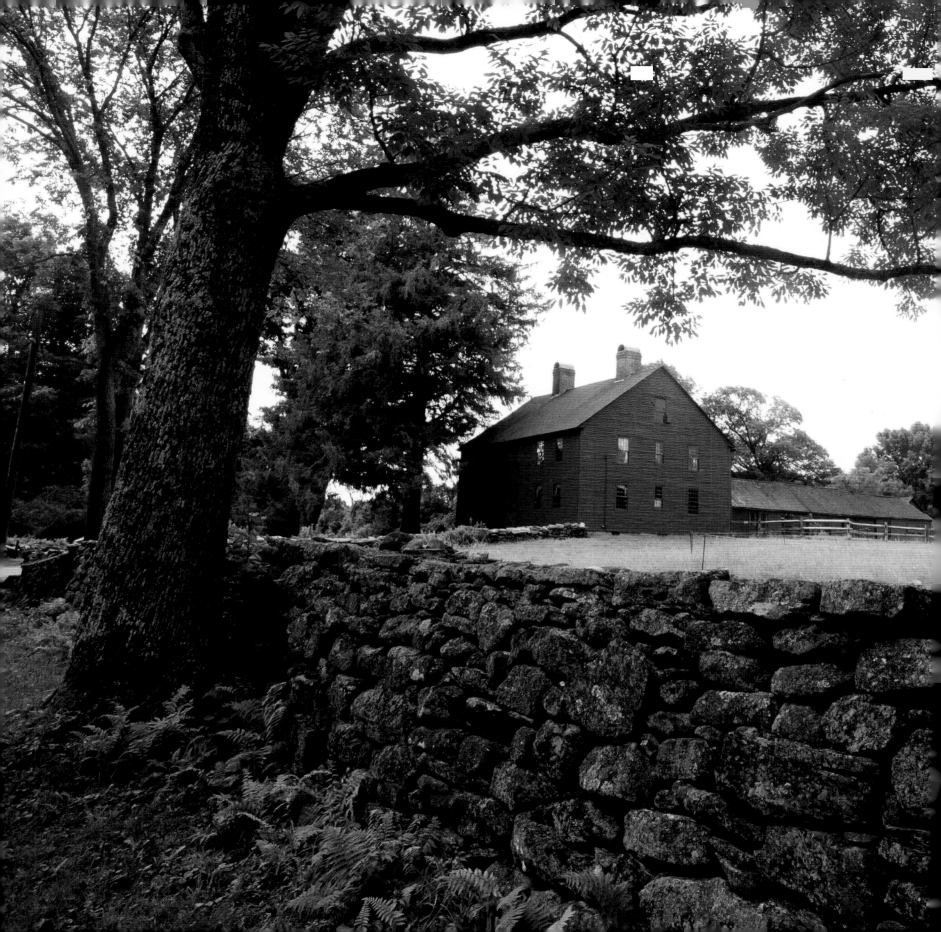

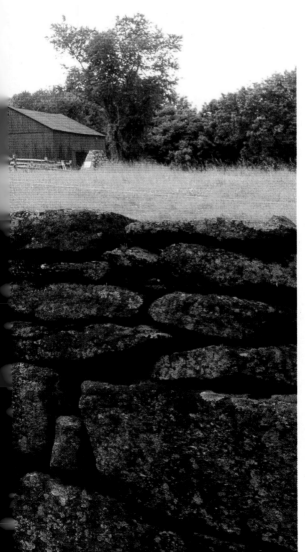

LEFT: The Nathan Hale Homestead in Coventry was built by the great patriot's father and brothers the year Nathan died. The homestead informs visitors about one of the inspirational heroes of the American Revolutionary War and displays some of his belongings. Minutes before Hale was hanged, he uttered the now famous words, "I only regret that I have but one life to lose for my country."

BELOW: The Washington–Rochambeau Revolutionary Route stretches 600 miles from Newport to Yorktown. A provision of the *Omnibus Public Land Management Act*, which President Obama signed in March 2009, designates the route as a National Historic Trail.

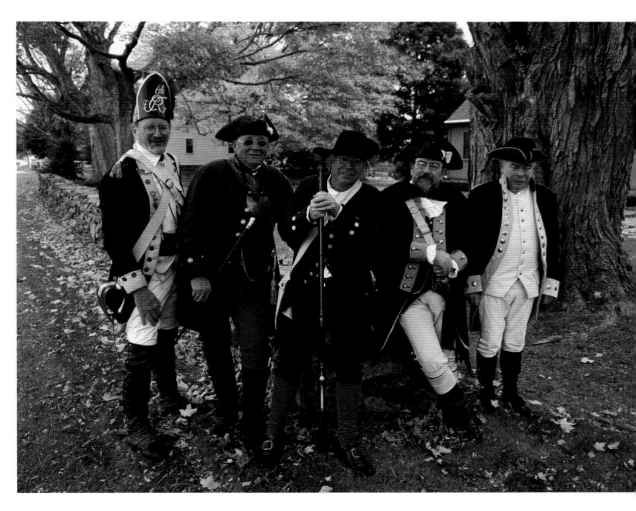

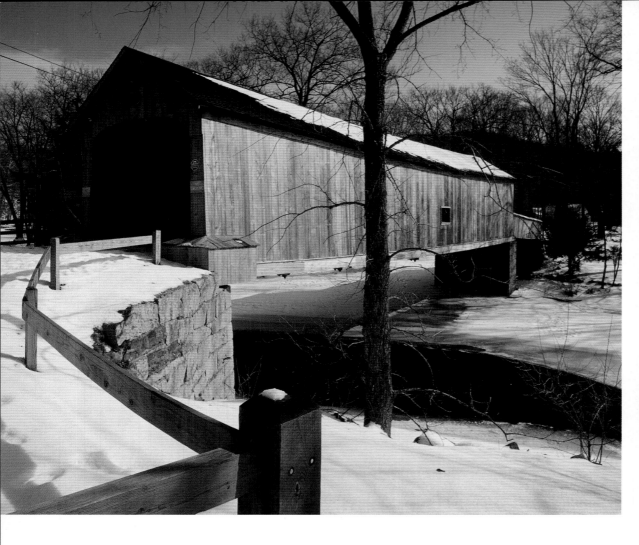

ABOVE: Built in 1873, the Comstock Bridge in East Hampton is a notable example of the Howe Truss system, which uses vertical iron rods and diagonal timbers. The 80-foot-long bridge crosses the Salmon River and is now closed to vehicular traffic.

RIGHT: Traffic continues to cross the West Cornwall Covered Bridge in Litchfield County. Built in 1841 over the Housatonic River, the narrow bridge is a photographer's delight.

FOLLOWING PAGE: Stonington, on the Pawcatuck River, was originally a trading post, welcoming settlers who arrived from Plymouth colony in 1649. It was named Southertown by Massachusetts and became part of Connecticut in 1662.

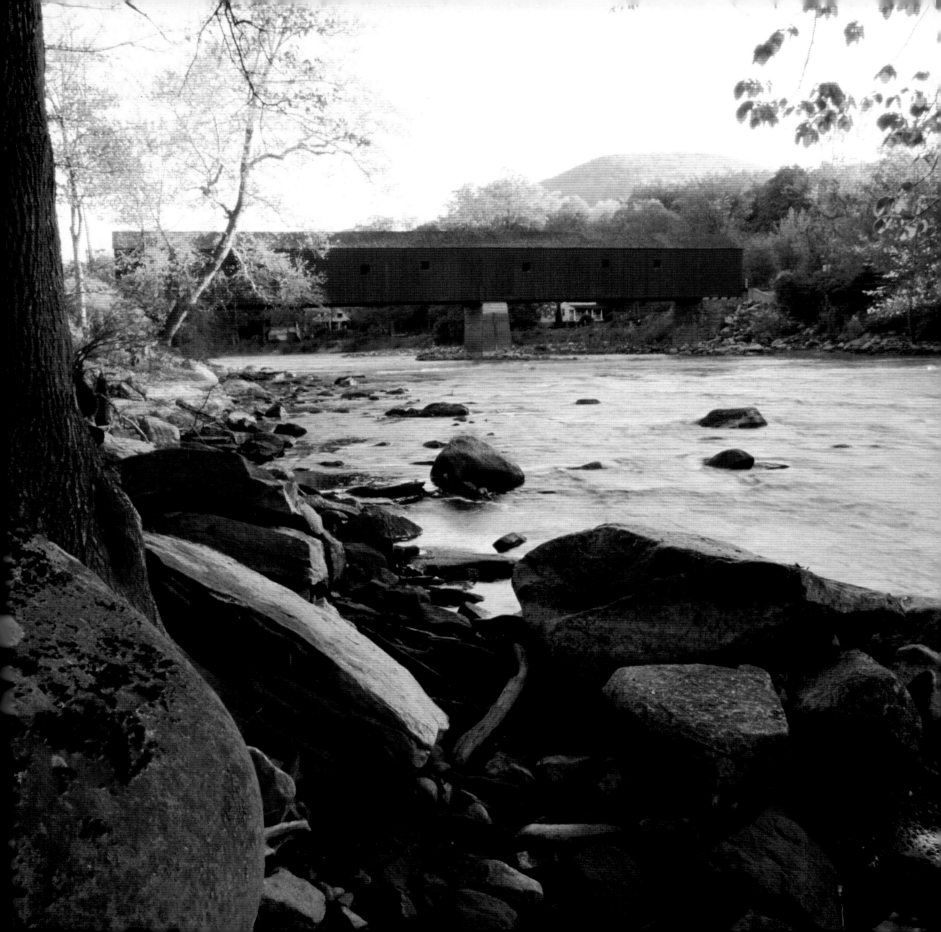

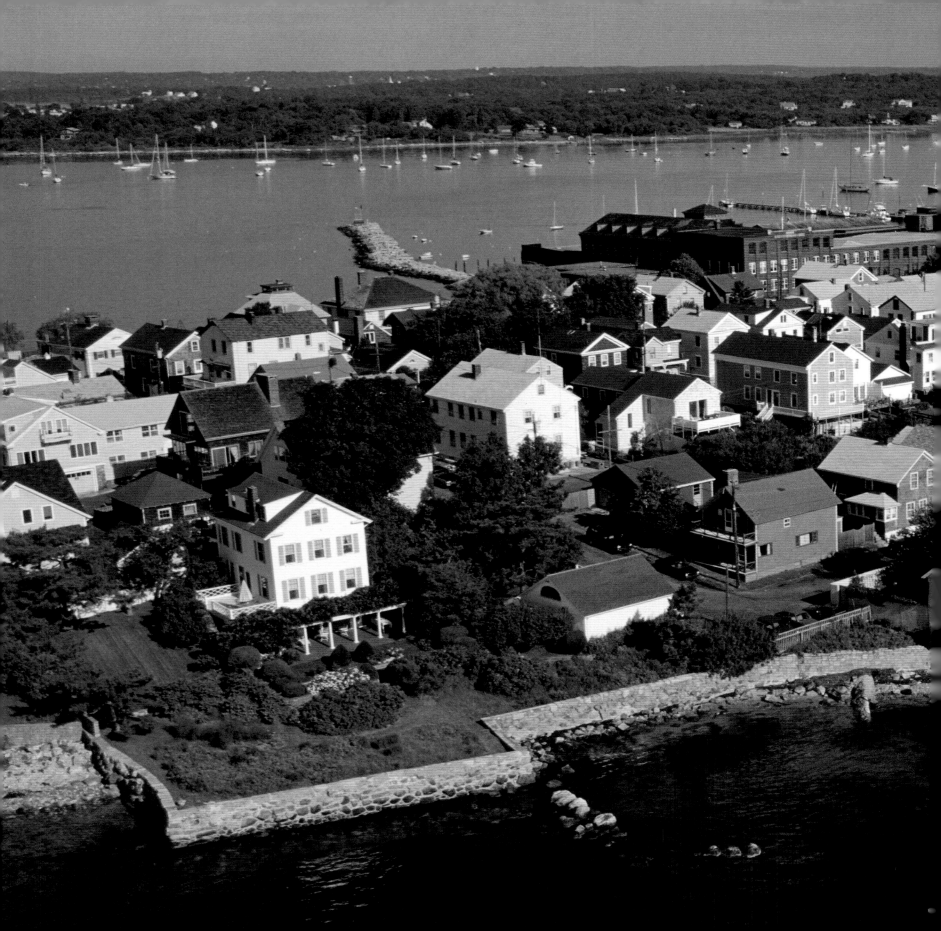

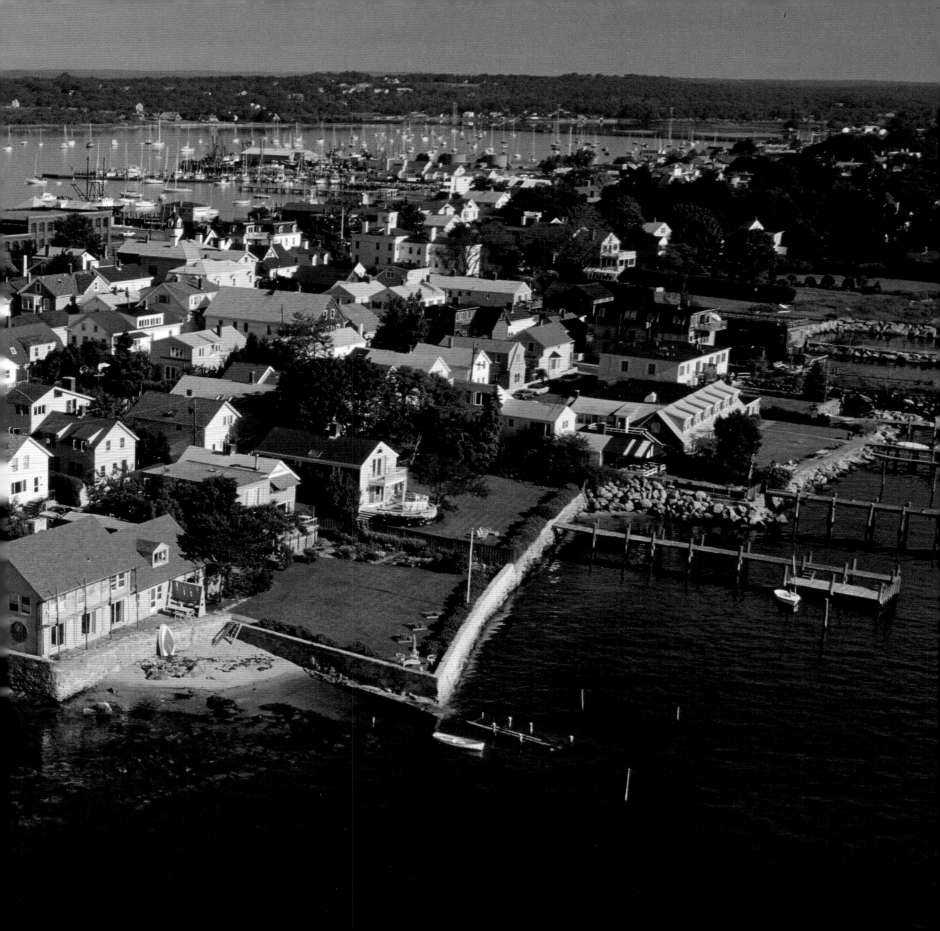

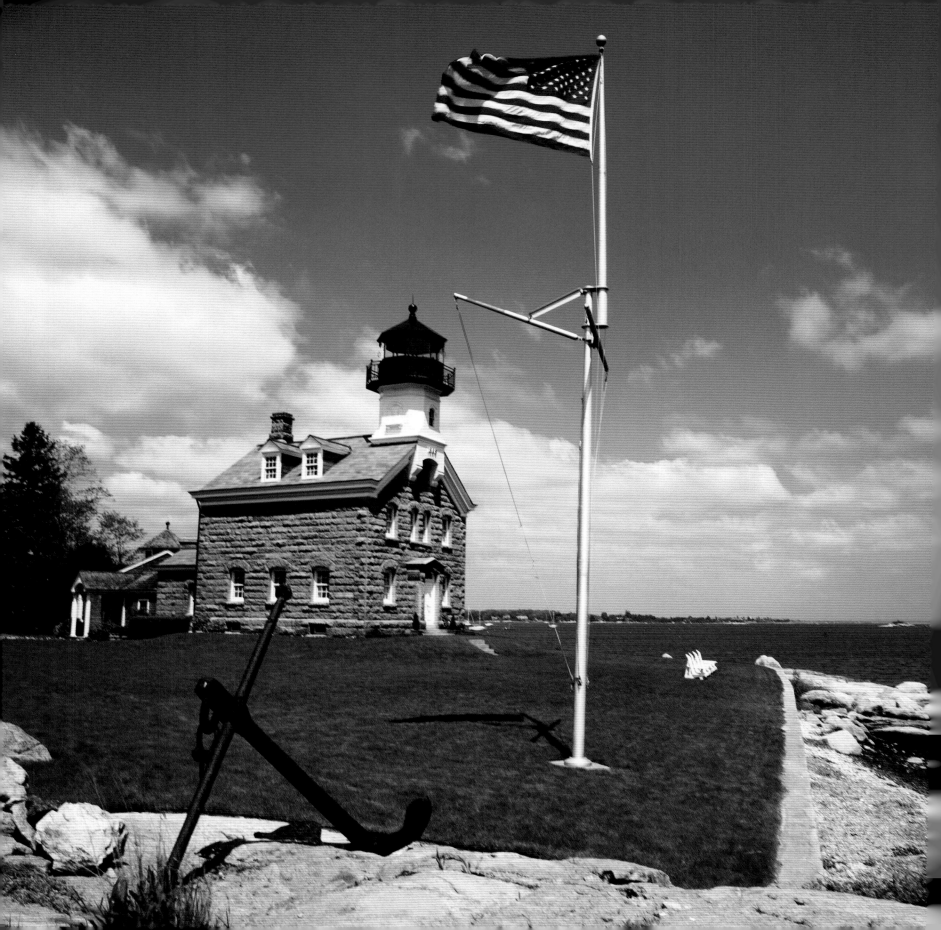

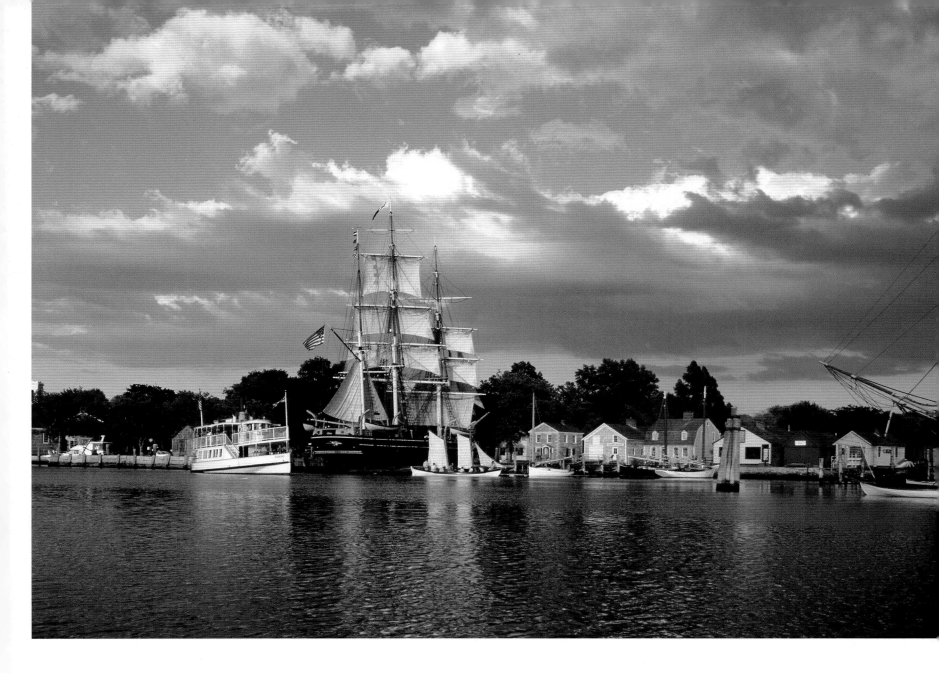

Mystic Seaport is now the world's largest maritime museum. The 19-acre working site of a 19th-century port includes more than 40 buildings open to the public. The biggest attraction, however, is Mystic's fleet of restored ships, including the *Charles W. Morgan*, one of the last surviving American wooden whaling vessels from the 19th century.

OPPOSITE PAGE: The Morgan Point Lighthouse near Noank is now privately owned. Completed in 1868, the 52-foot-tall lighthouse was discontinued in 1921. The exterior has been restored to its original appearance, and the interior converted to a private residence.

Essex's harbor attracts many enthusiasts with its beautiful facilities and numerous boating festivals. This view is taken from the Connecticut River Museum at the end of Main Street.

OPPOSITE PAGE: Essex, which styles itself as the "best small town in America," boasts a beautiful marina on the Connecticut River. The area is known for its charming street scenes and comfortable way of life.

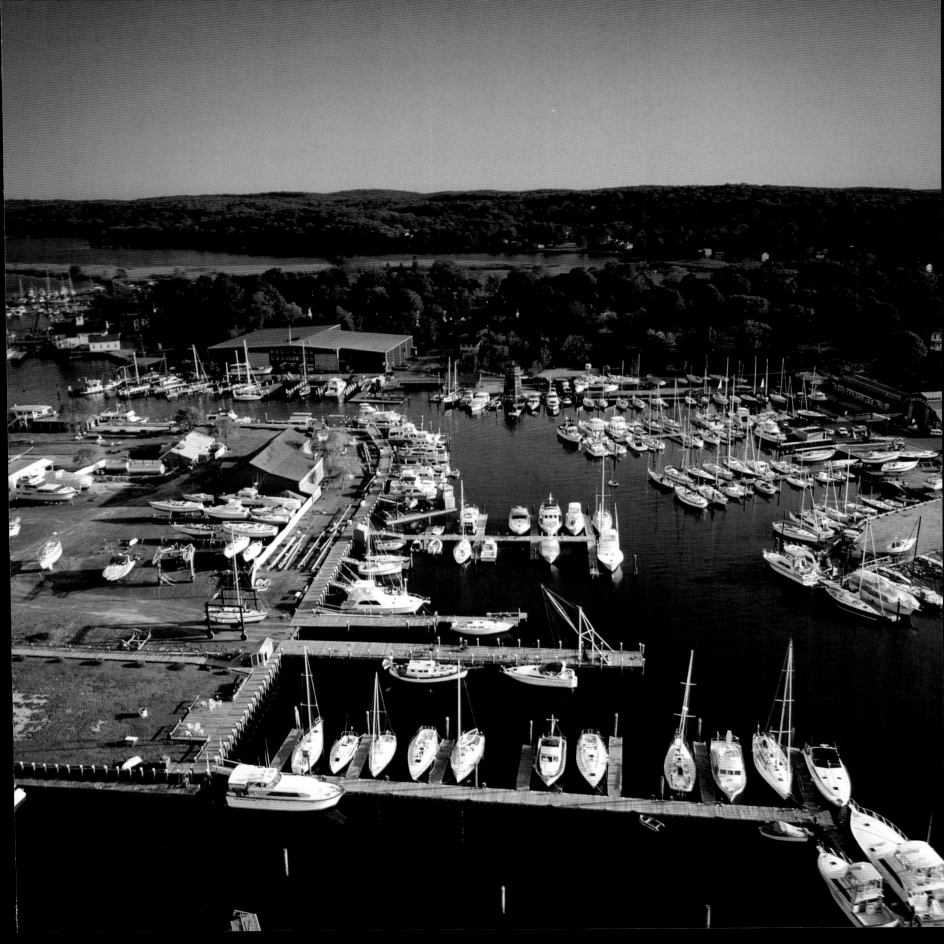

Main Street in Essex boasts numerous restored 18th- and 19th-century homes. The town is also famous for the Essex Steam Train, which runs through Deep River, Chester and Selden Neck State Park.

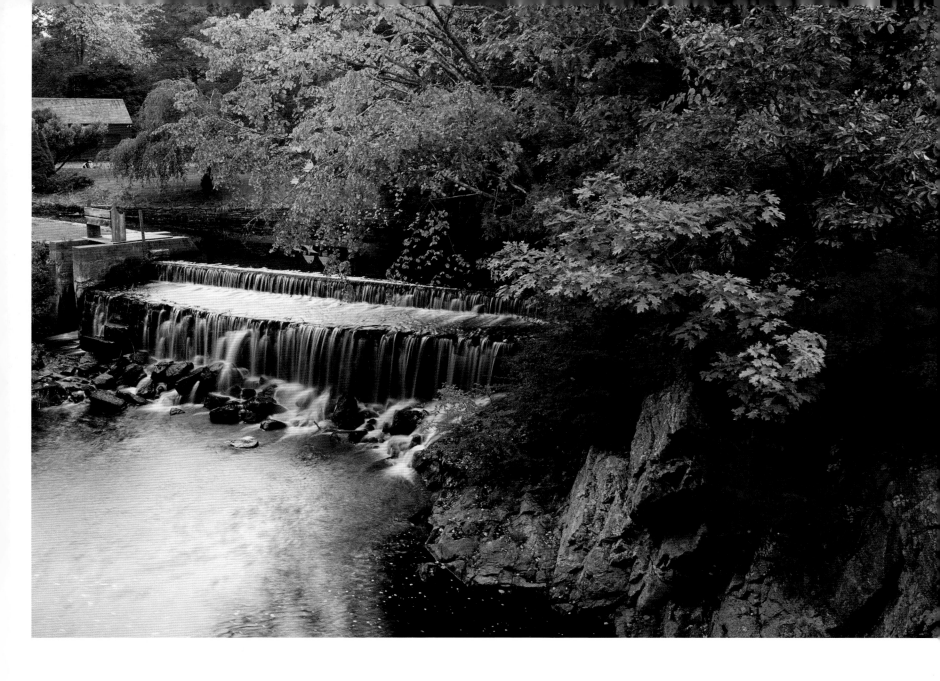

The town of Old Lyme was founded in the 1640s and later reinvented itself as a summer art colony. Old Lyme occupies 27 square miles of shoreline, marsh, wetlands and forest.

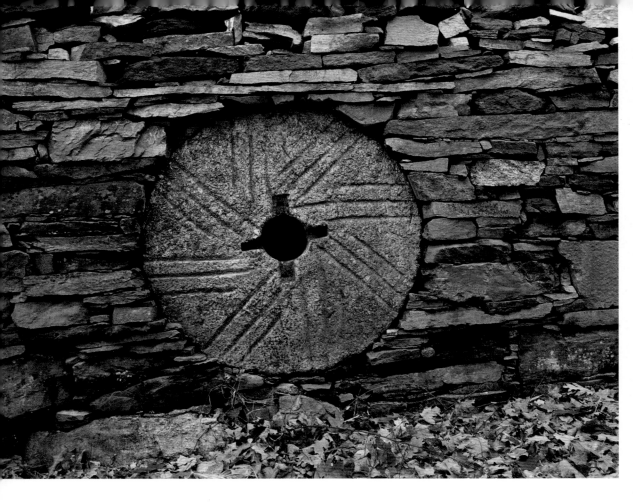

ABOVE: The stone walls of Connecticut often tell a story about the area or its builders. Some walls are now in disrepair, others are meticulously maintained; some are little more than piles of boulders that farmers hauled off their fields, others are elaborate constructions. This marvelous example incorporates a millstone.

RIGHT: Branford Mansion was built as a summer home for Morton Plant at a cost of $3 million in 1903 — a time when the local bank in Groton contained only $300,000! This palatial building features an extraordinary two-story fireplace, Italian marble stairs and beautifully carved woodwork.

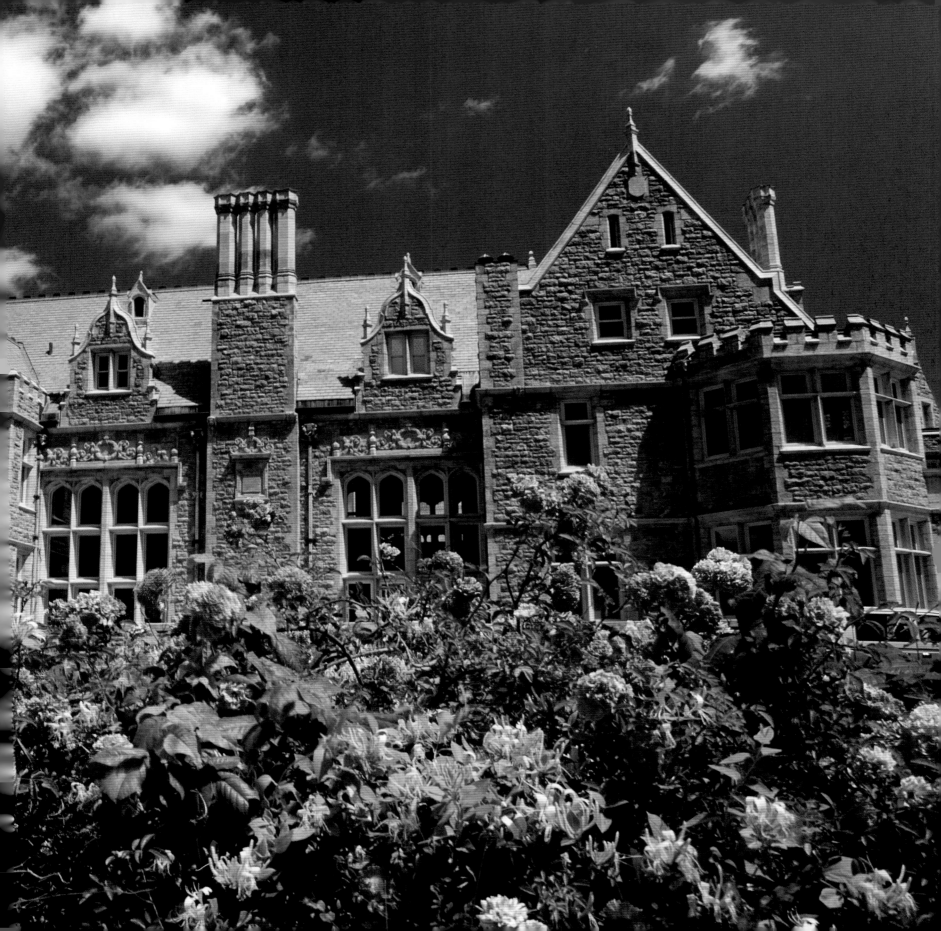

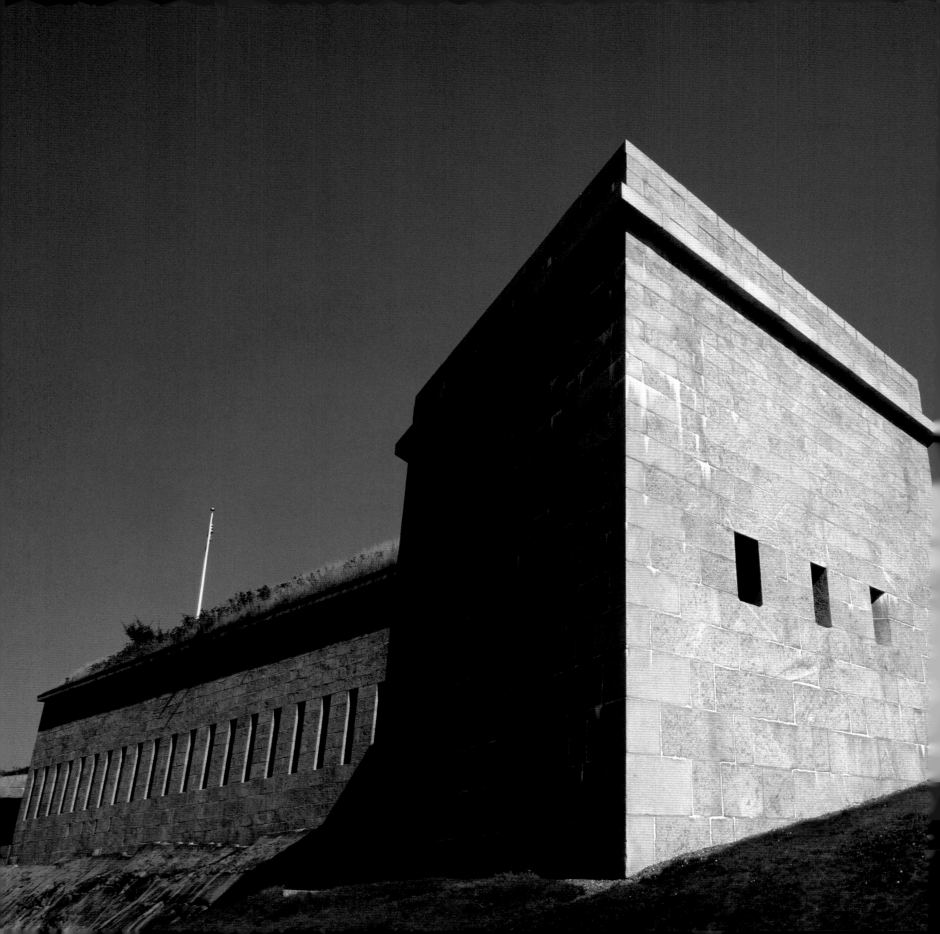

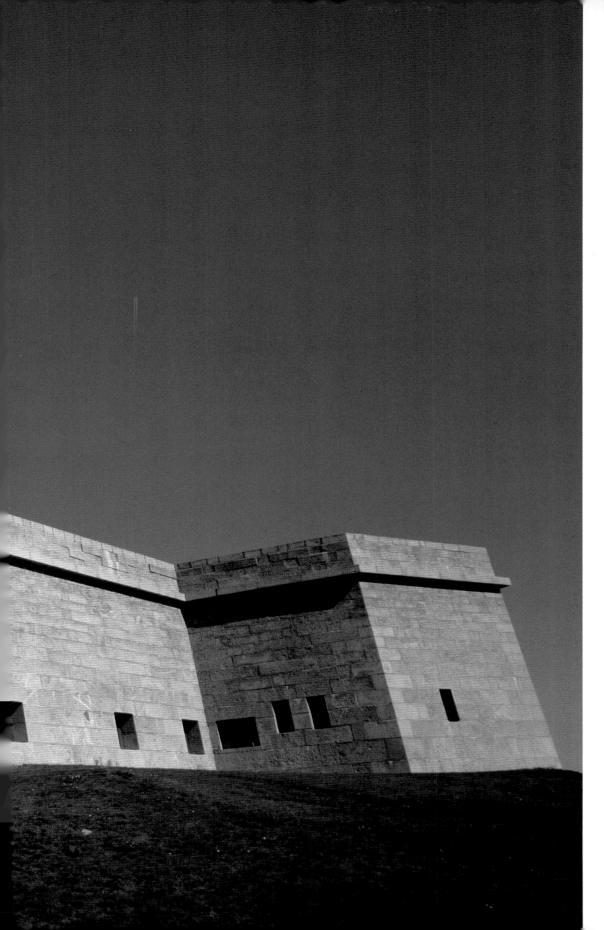

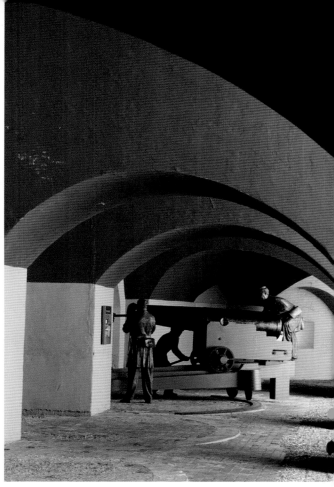

ABOVE: Fort Trumbull's visitors may walk the battlements, see restored living quarters and learn more about its history through interactive, multimedia displays. The area also boasts excellent fishing along the 500-foot pier at the base of the fort.

LEFT: Fort Trumbull State Park encompasses this massive defense work built between 1839 and 1852 as one of a series of 42 forts known as the Third System. The forts were constructed to guard the coastline, and many of them, including Fort Trumbull, incorporate Egyptian Revival features in their architectural design.

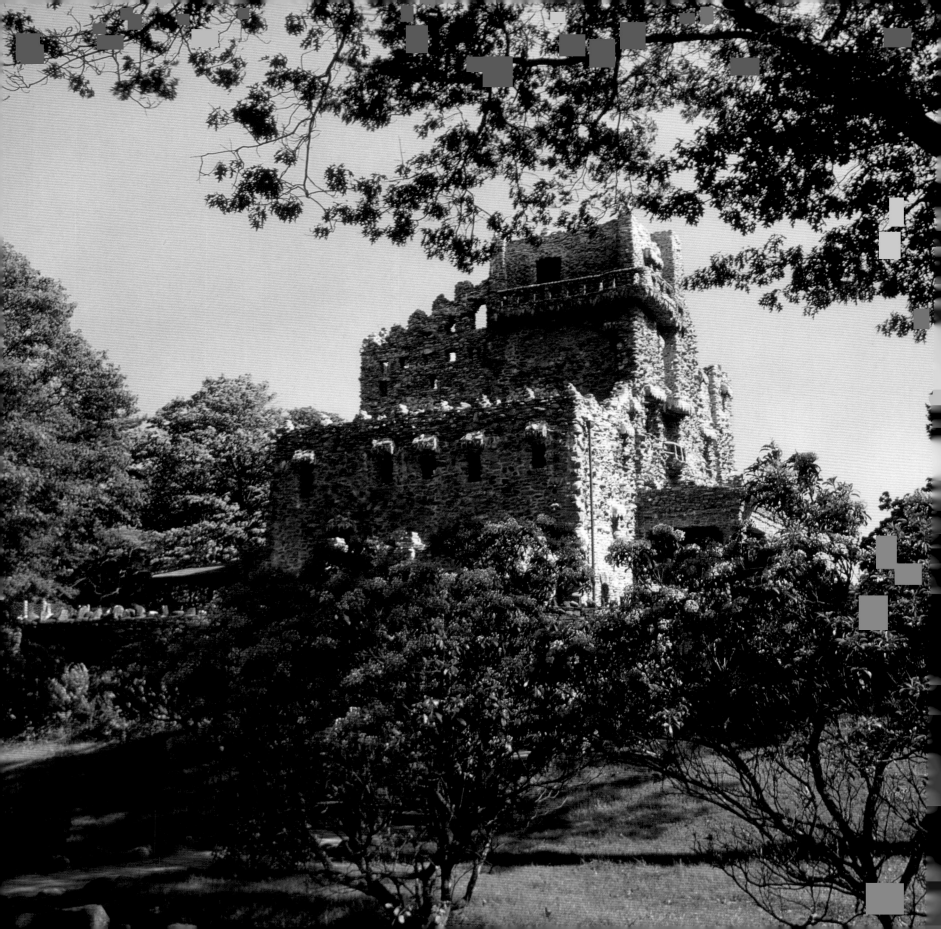

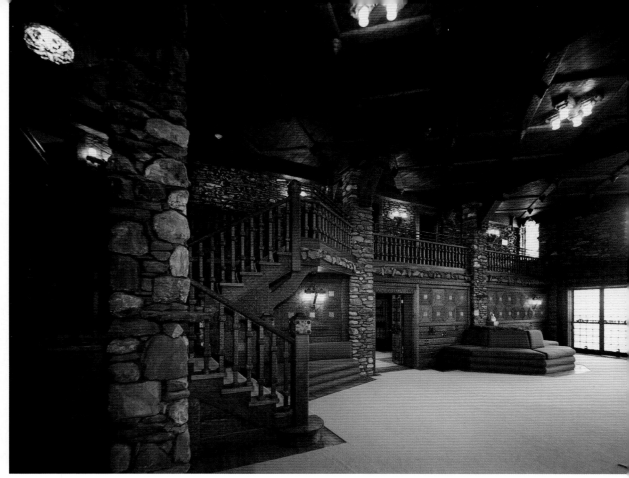

ABOVE: Although designed to resemble a medieval castle with turrets and battlements, the home has many modern — and bizarre — features. Furniture was set on wheels and tracks, a series of mirrors allowed Gillette to see who was at the door while still in bed, and trick locks frustrate visitors.

LEFT: Often seen as the antithesis of New England architectural austerity, Gillette Castle is a fantastically ostentatious creation. William Gillette (1853–1937) was an eccentric playwright and actor who made much of his fortune playing Sherlock Holmes on the stage. His stone folly looks over the Connecticut River.

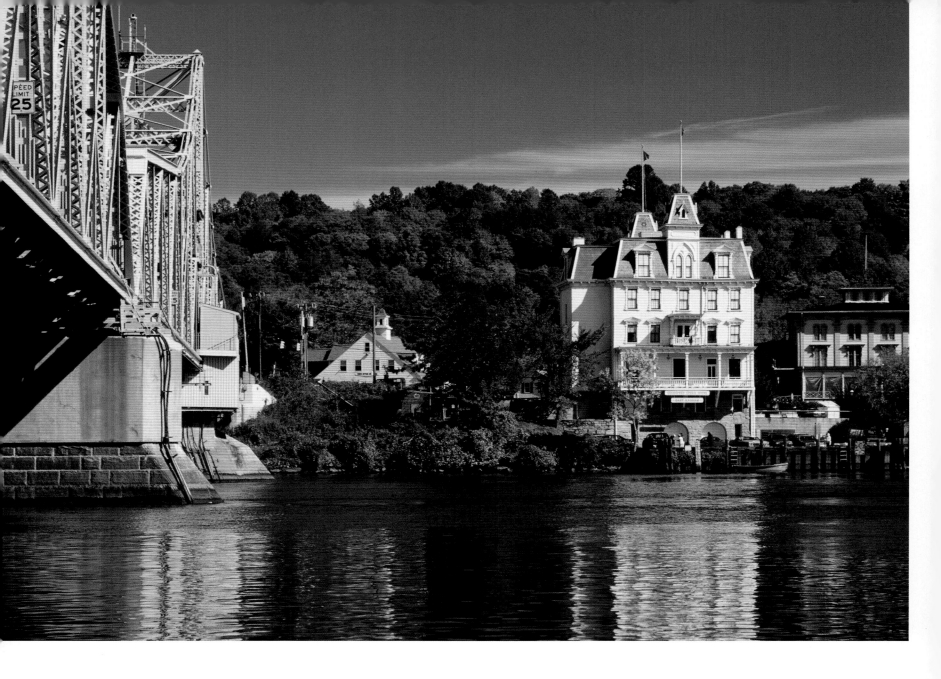

In October 1877, more than 600 people packed the opening night of the Goodspeed Opera House in East Haddam. After Goodspeed's decline, the building served as a military base and later a general store. The opera house was rededicated in 1963 and has achieved acclaim as a center of musical theater.

OPPOSITE PAGE: Connecticut College is a prestigious co-educational school known for its small class sizes and emphasis on study abroad. The college was founded in 1911 in response to Wesleyan University's decision two years earlier to bar women from studying at that institution.

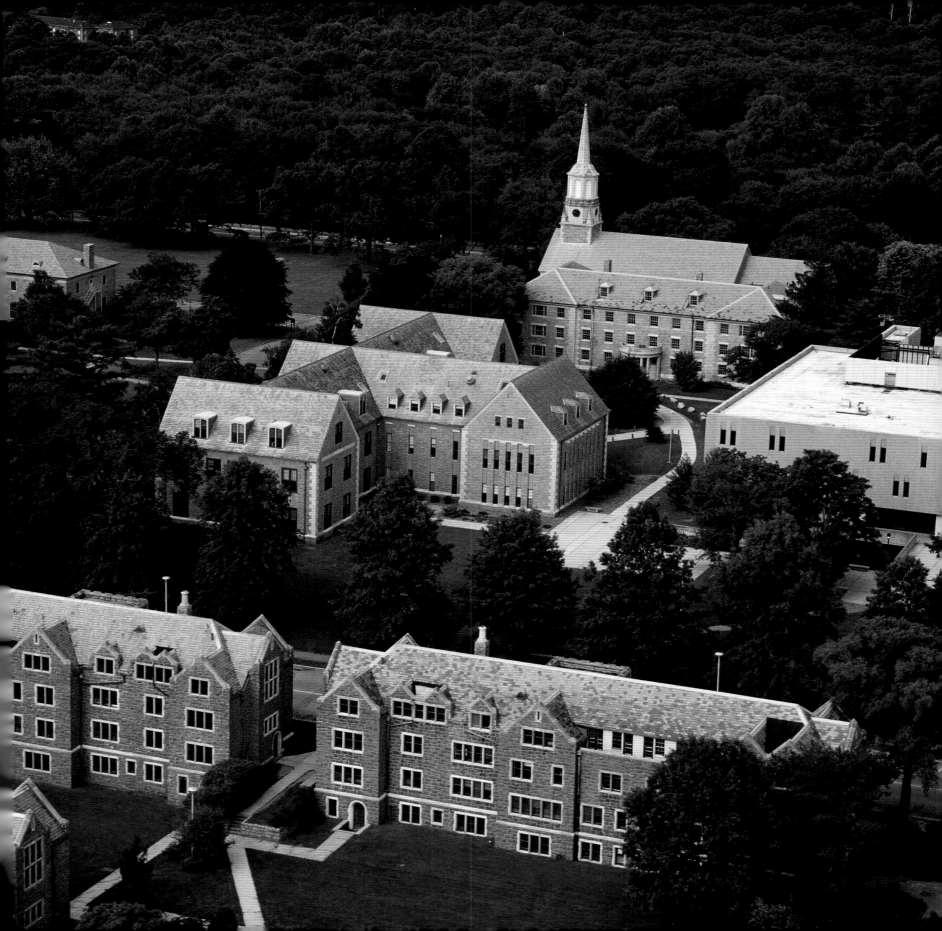

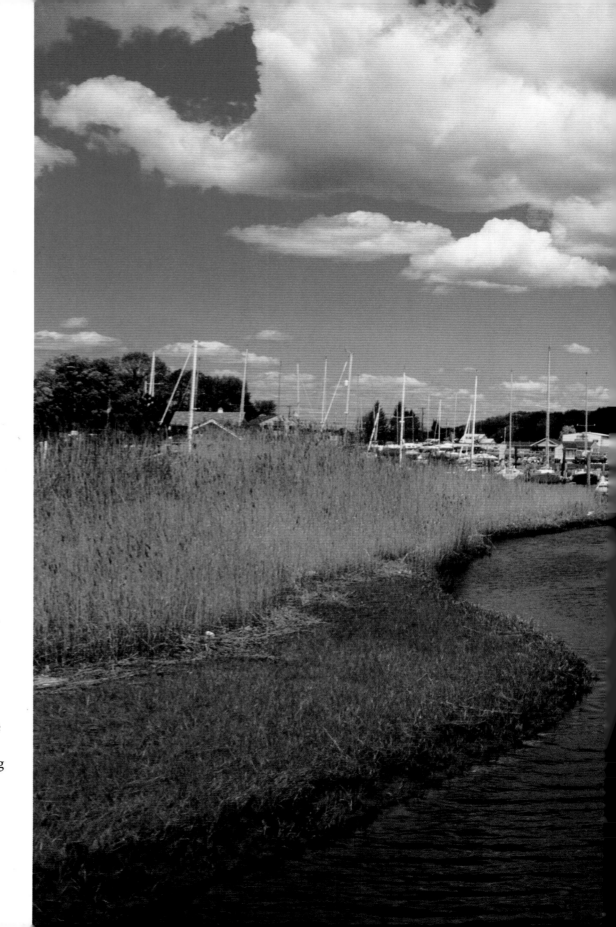

Clinton, in Middlesex County, was laid out as a plantation in 1663 and later designated a town. The economy of the town, which overlooks Long Island Sound, centered on fishing and shipbuilding, as well as farming. In recent years, Clinton has become a bedroom community of New Haven.

FOLLOWING PAGE: Hammonasset Beach State Park is the largest shoreline park in Connecticut, and its beautiful stretch of fine sand is more than two miles long. The park opened in 1920, having earlier been a testing site for the Winchester Repeating Arms Company. More than one million people visit annually.

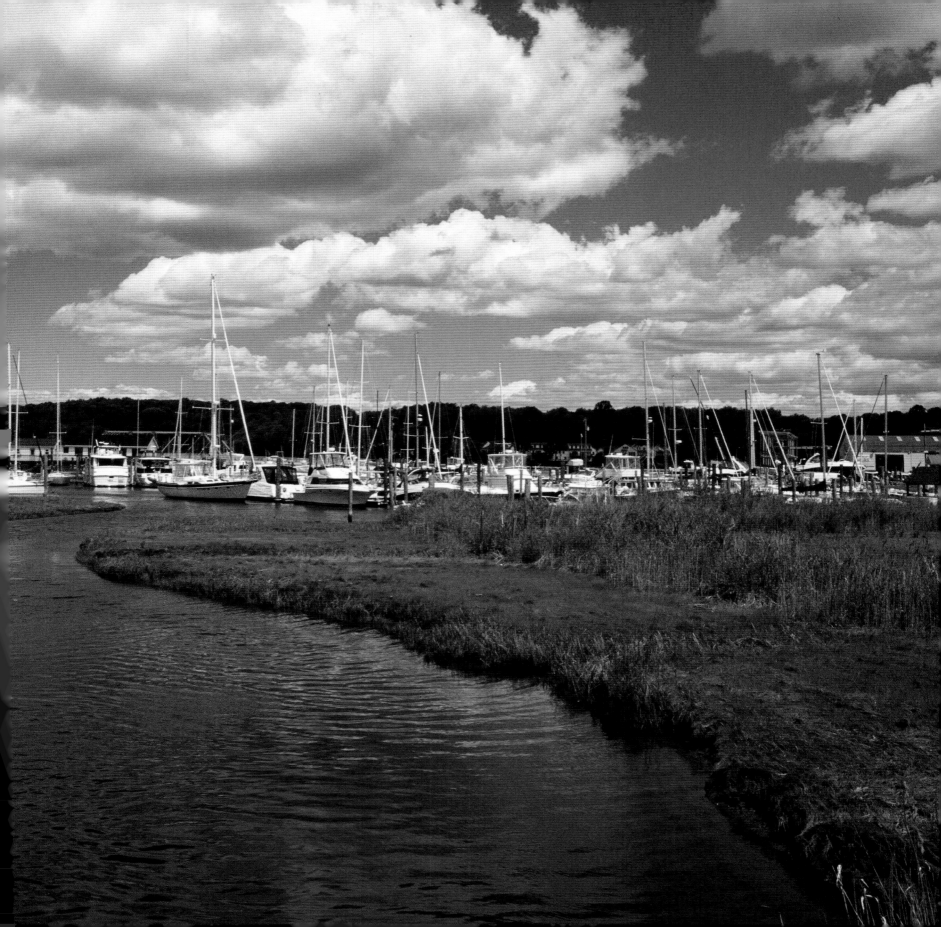

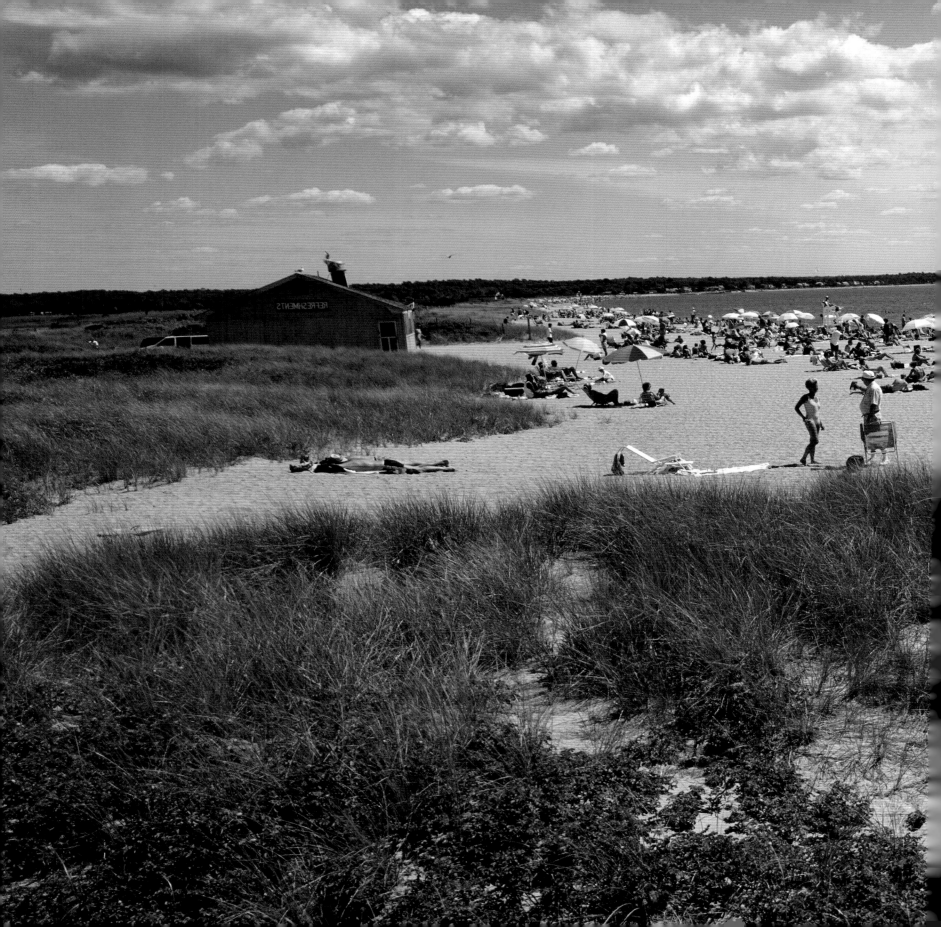

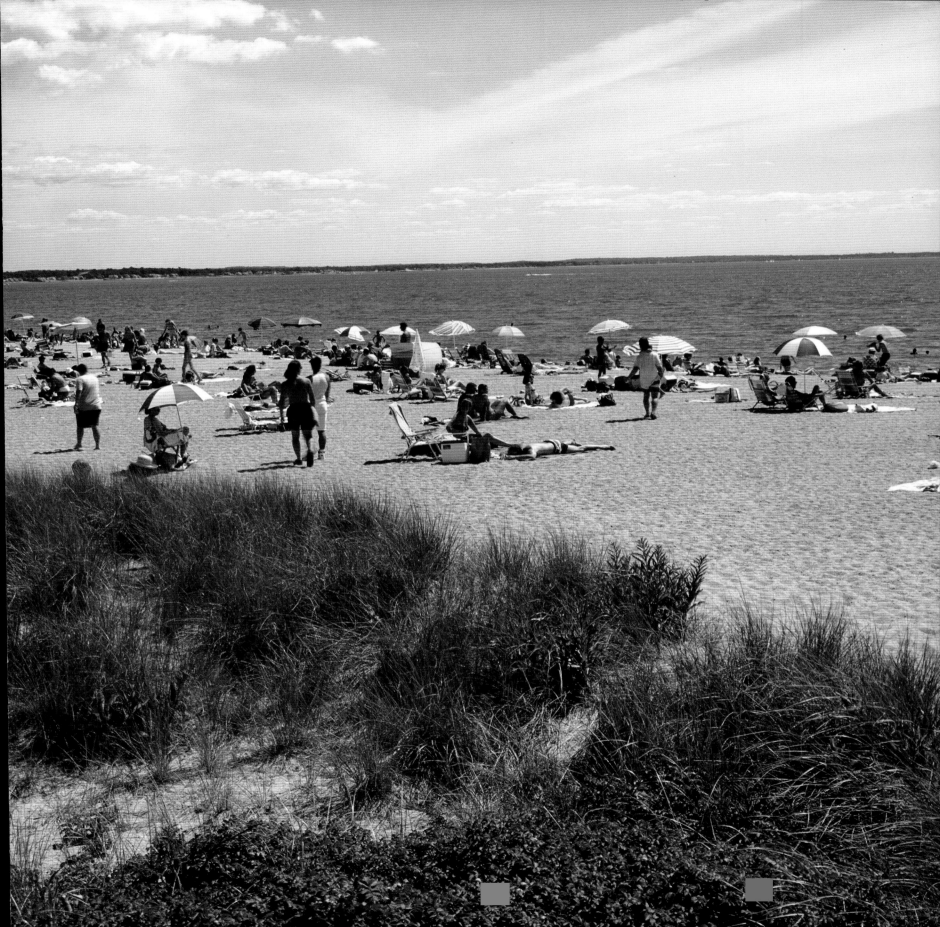

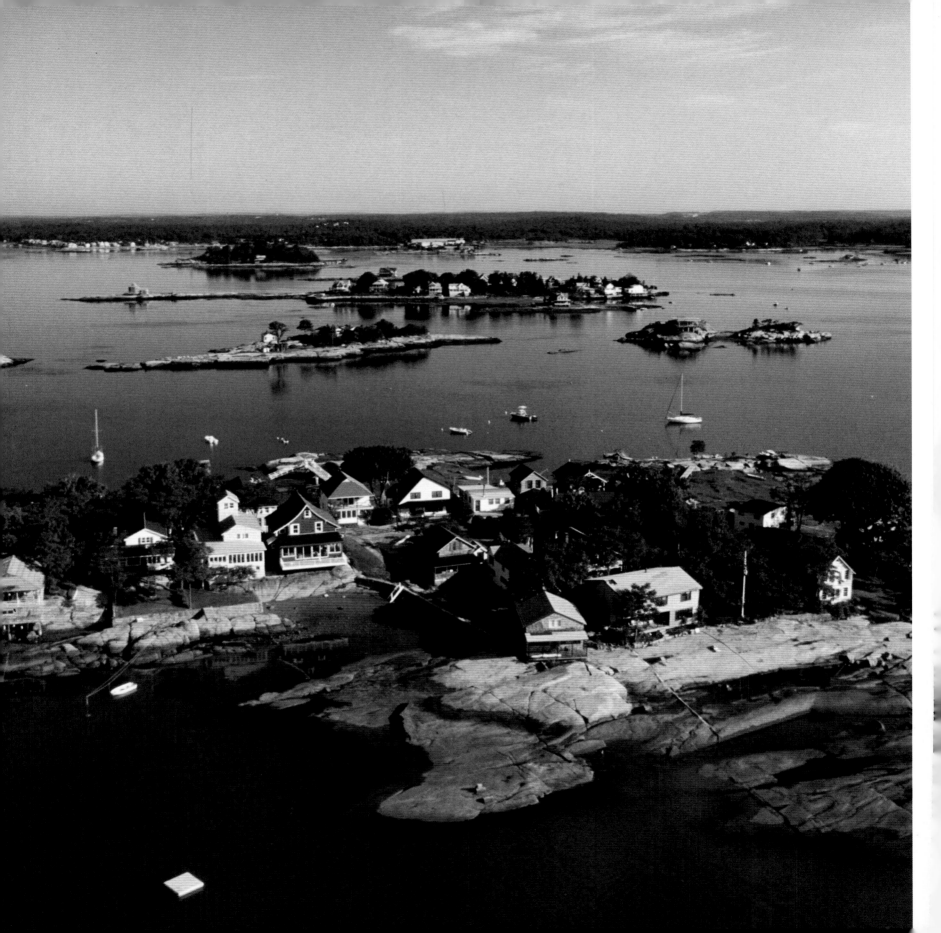

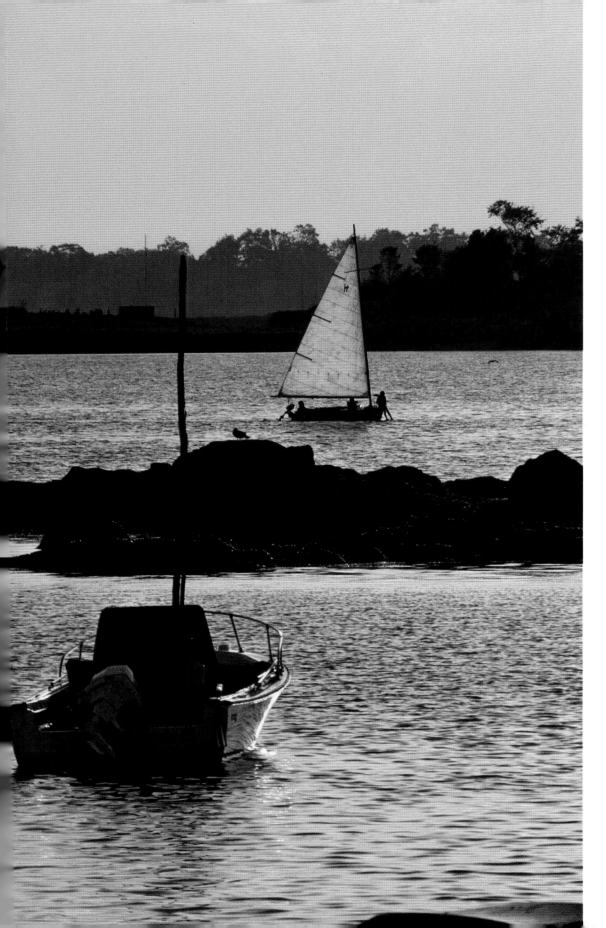

The Thimble Islands form an archipelago in Long Island Sound, southeast of Branford. Many of the 365 islands appear as little more than boulders, even at low tide, but others sustain tiny communities.

The islands are composed of pink granite and were known to the Mattabeseck Indians as "the beautiful sea rocks." The islands are now home to a select group of wealthy residents, but they have a colorful past. According to legend, Captain Kidd buried his treasure here.

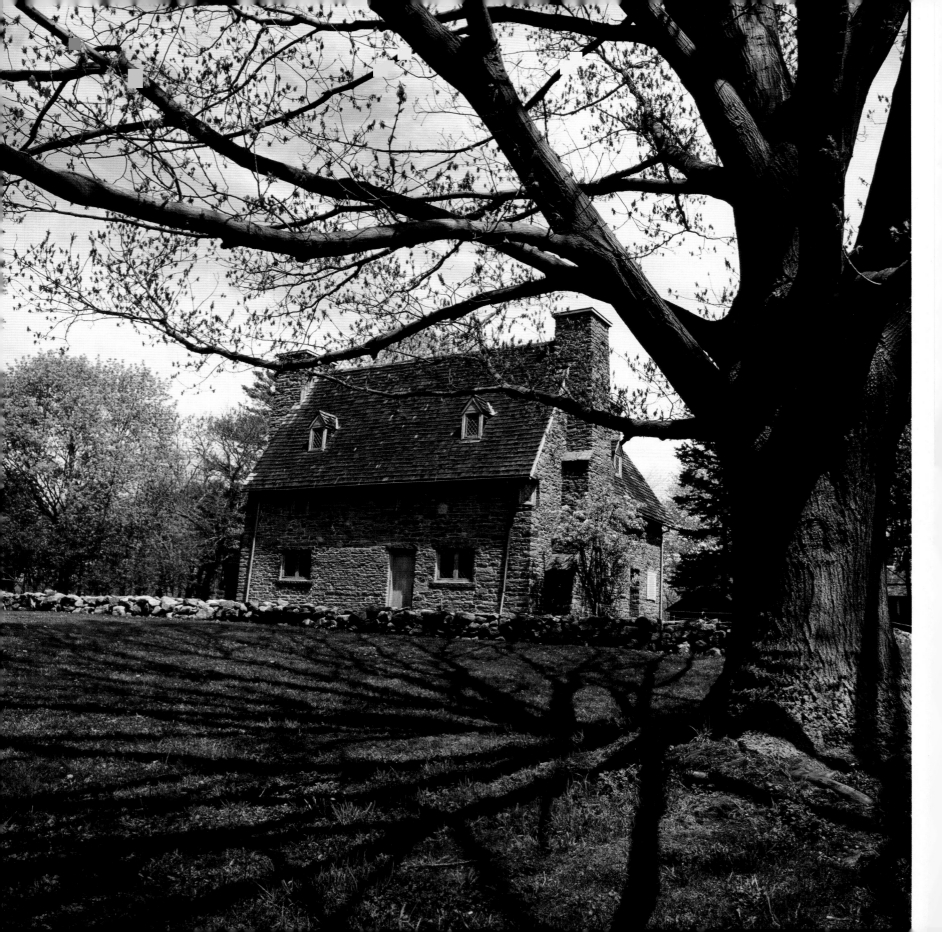

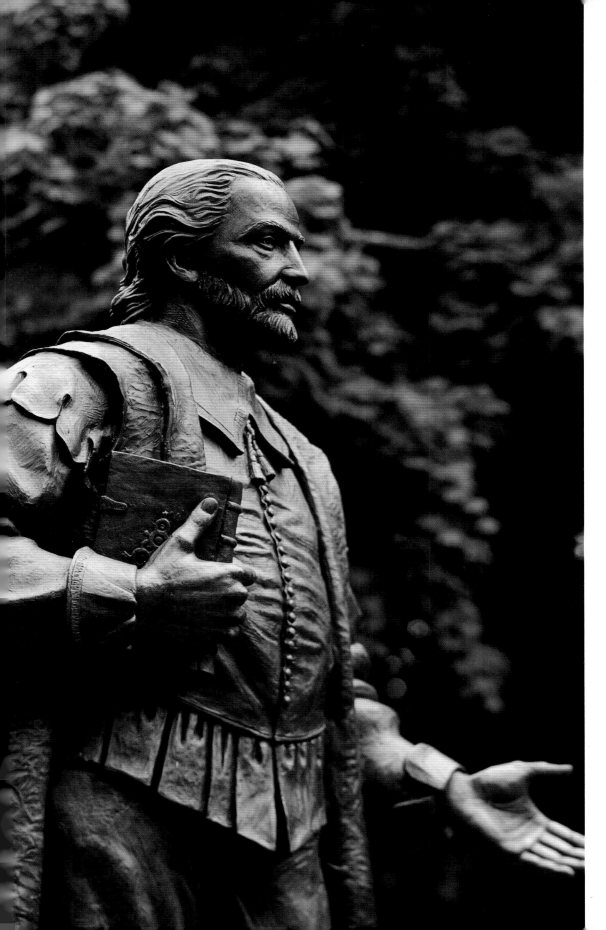

Only 32 years after the founding of Jamestown, a group of English Puritans led by their minister, the Reverend Henry Whitfield, arrived in the New World and began to settle the area that is now known as Guilford.

The Henry Whitfield House (far left), built in 1639, is a rare example of post-medieval domestic architecture in America. The building, which also served as a fort, is notable for its steeply pitched roof and casement windows. Massive stone walls helped preserve the building, which is New England's oldest surviving stone house and has been a museum since 1899.

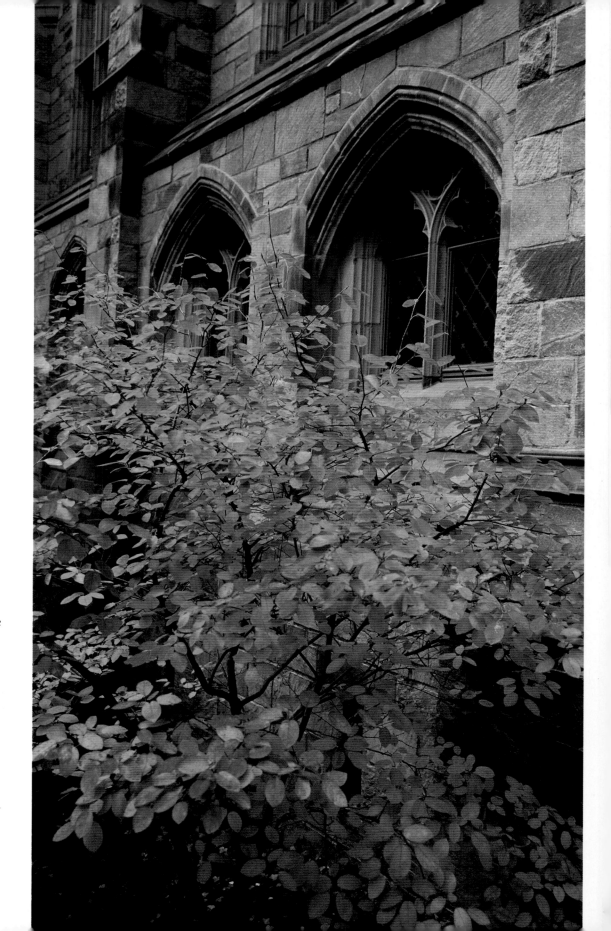

Founded in 1701, New Haven's Yale University has become one of the most prestigious places of higher learning in the world. Five American Presidents attended Yale: William Howard Taft, Gerald Ford, George H. W. Bush, Bill Clinton and George W. Bush. Other famous alumni include Samuel Morse, inventor of the Morse code, and Noah Webster, who compiled the country's first dictionary.

The university was named for Elihu Yale, a Welsh merchant who donated the proceeds of nine bales of goods, 400 books and a portrait of King George to the fledgling institution.

Branford College (far right) is the second oldest of the 12 residential colleges at Yale.

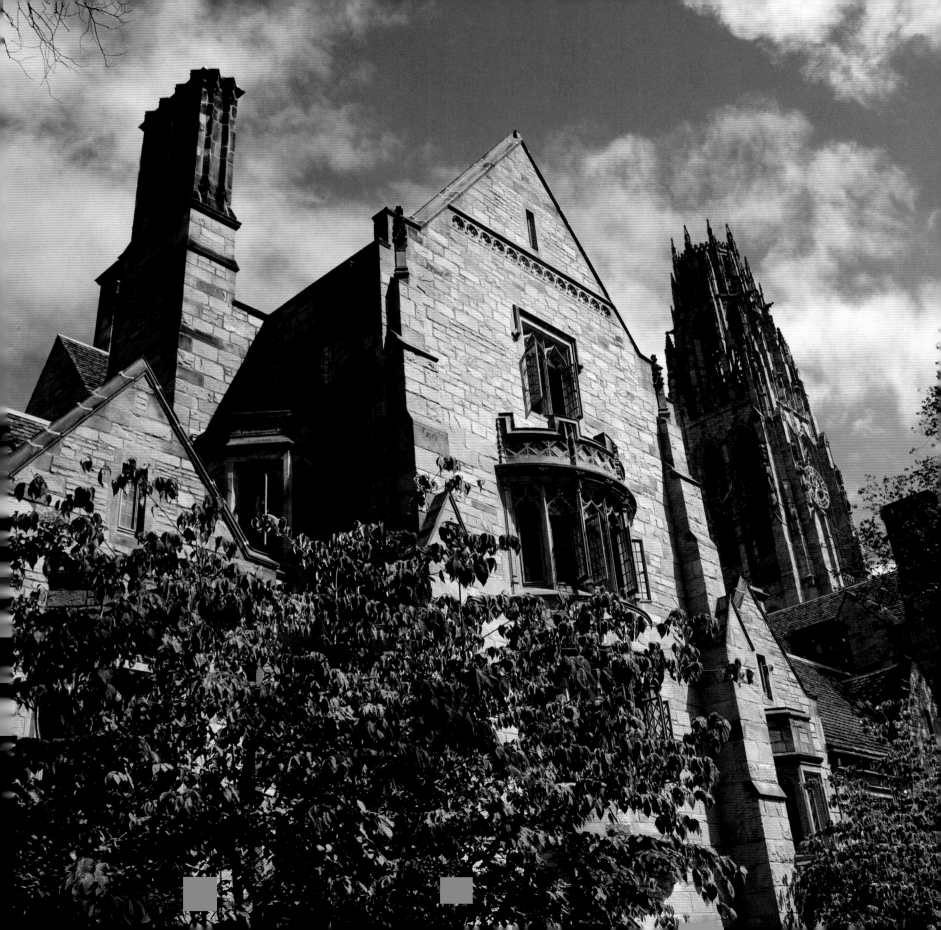

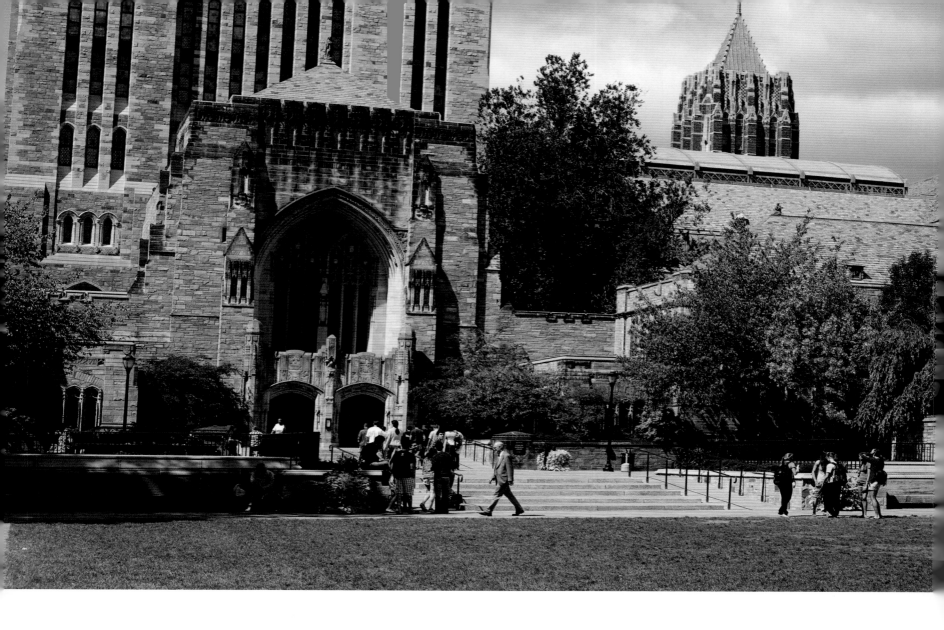

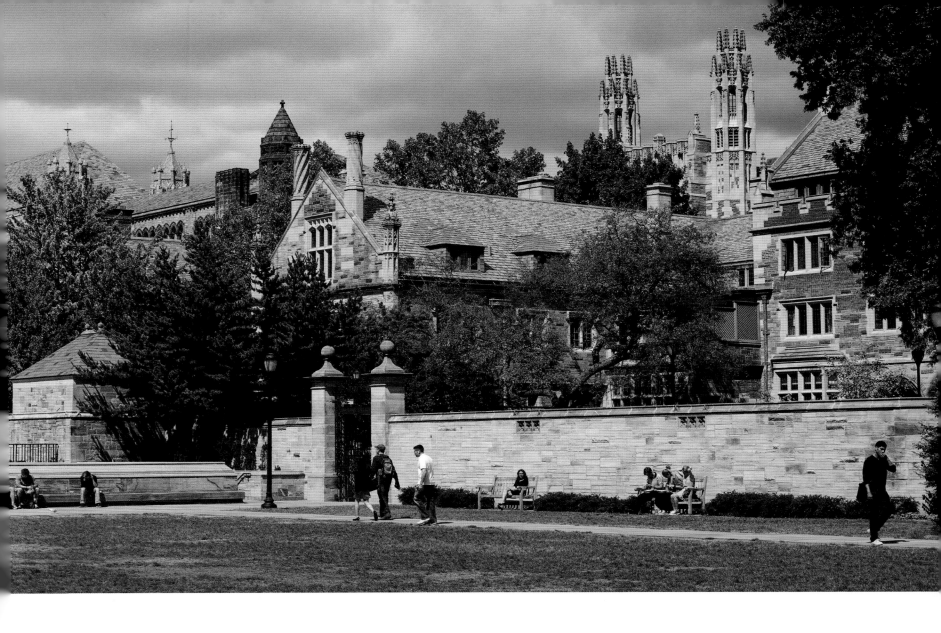

Yale's campus is spread across much of New Haven's downtown core, but many of its central facilities are located along the western edge of the New Haven Green. The oldest building on campus is Connecticut Hall, built in 1752. Today, 11,000 students from every state and more than 110 countries study here.

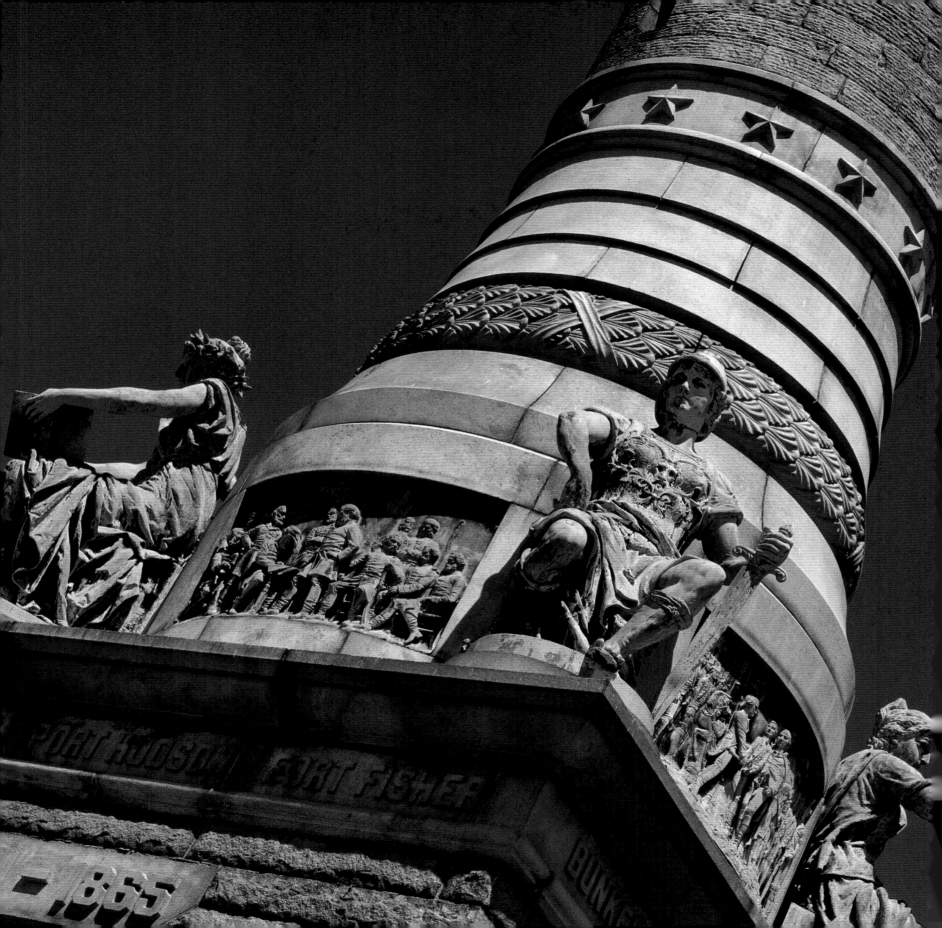

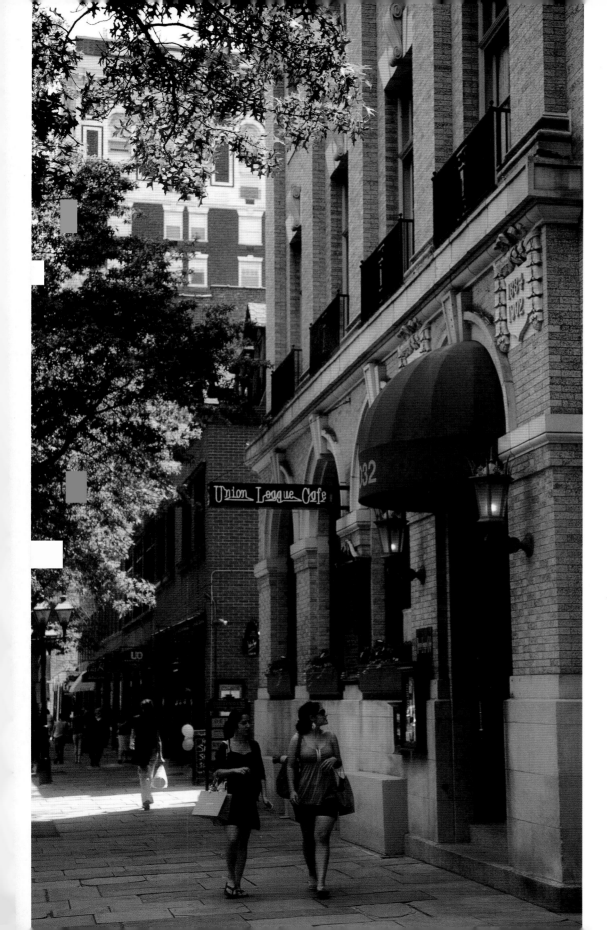

New Haven, bolstered by Yale University and other centers of research and technology, supports a healthy retail sector. The city has preserved many historic buildings.

OPPOSITE PAGE: East Rock Park is a popular recreational area in New Haven that offers great views of the city and surrounding communities. The park is the site of the 112-foot-tall Soldiers and Sailors Monument, which honors those who gave their lives in the Revolutionary and subsequent wars.

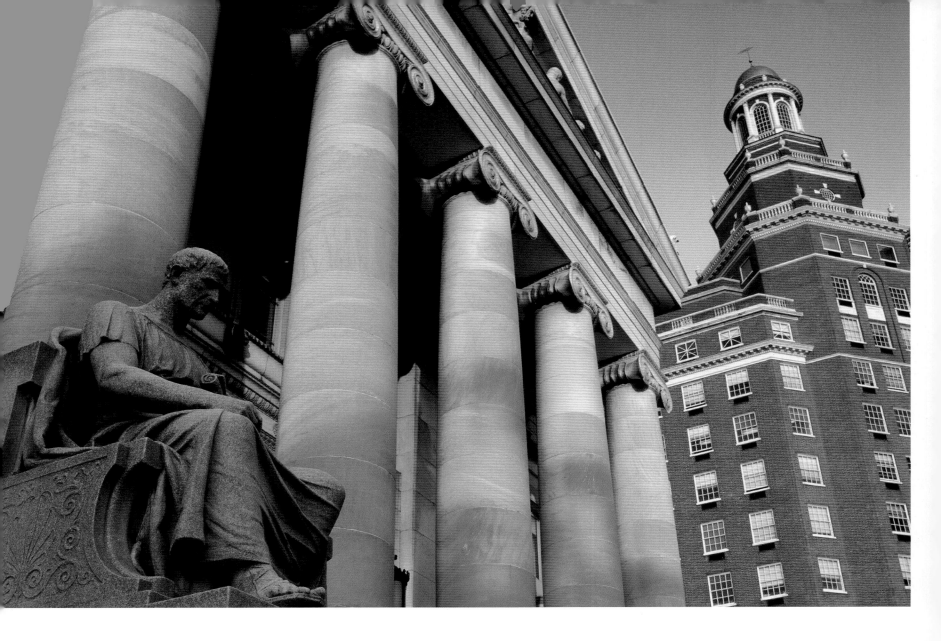

New Haven County Courthouse opened in 1914 and was one of several buildings commissioned by the city to bolster its City Beautiful movement. The structure, which mixed Beaux-Arts principles and Neo-Classical style, was roughly modeled after St. George's Hall in Liverpool, England.

OPPOSITE PAGE: The 16-acre New Haven Green is located in the heart of the city and is the central of the original nine squares laid out by the Puritan colonists in 1638. The Green and the three churches erected between 1812 and 1816 have remained a focus of New Haven — the first planned city in the country.

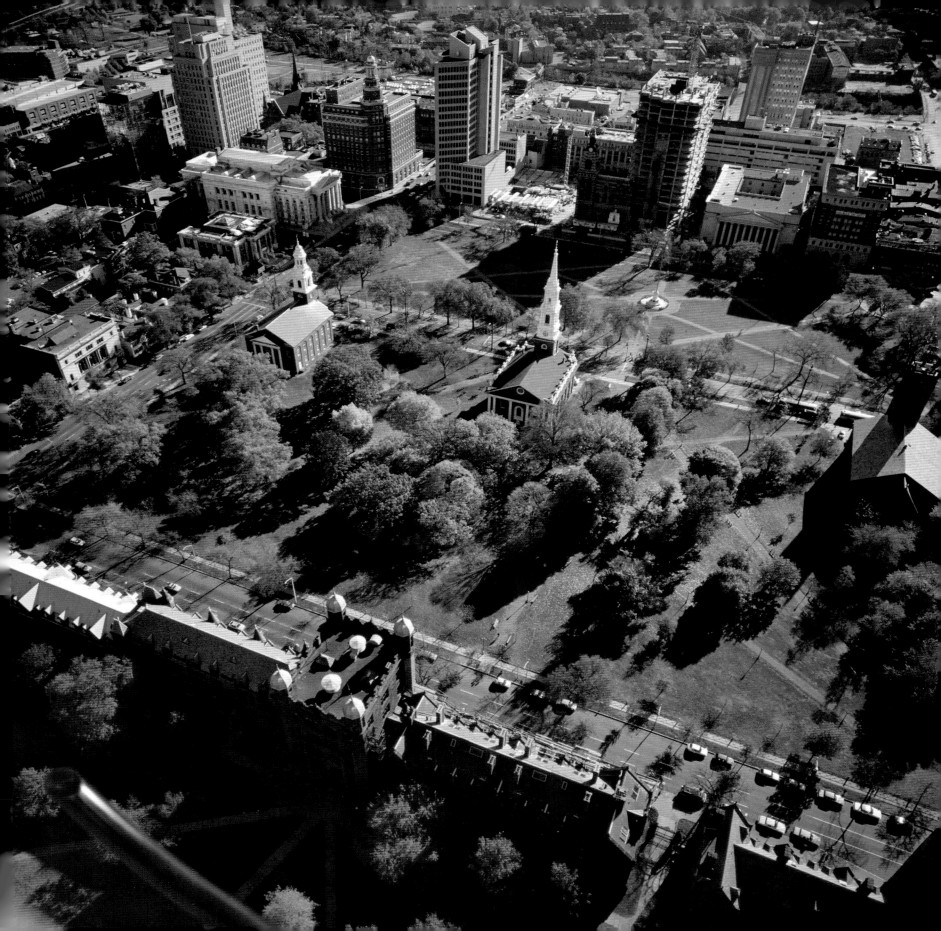

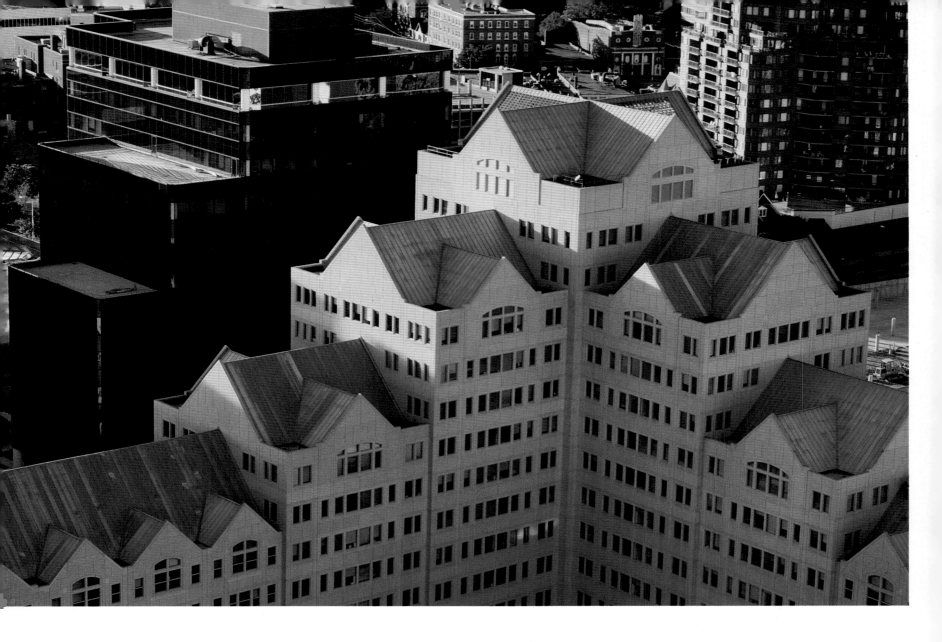

Canterbury Green is a distinctive apartment building in downtown Stamford, the fourth largest city in Connecticut and home to a number of corporate headquarters.

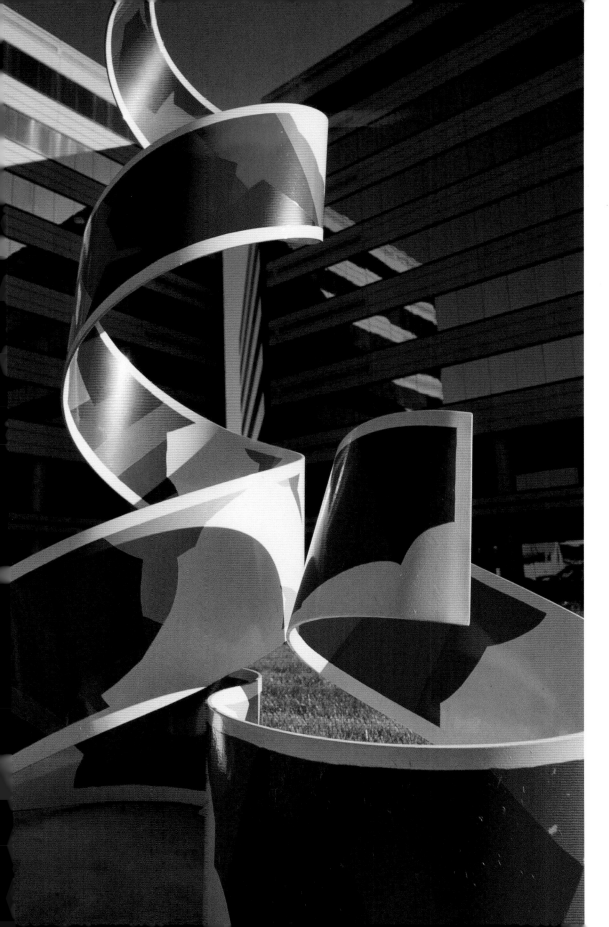

Connecticut is often associated with Colonial houses, red barns and stone walls, but the state offers many contemporary touches as well. This colorful sculpture stands in front of an office near Stamford Harbor Park.

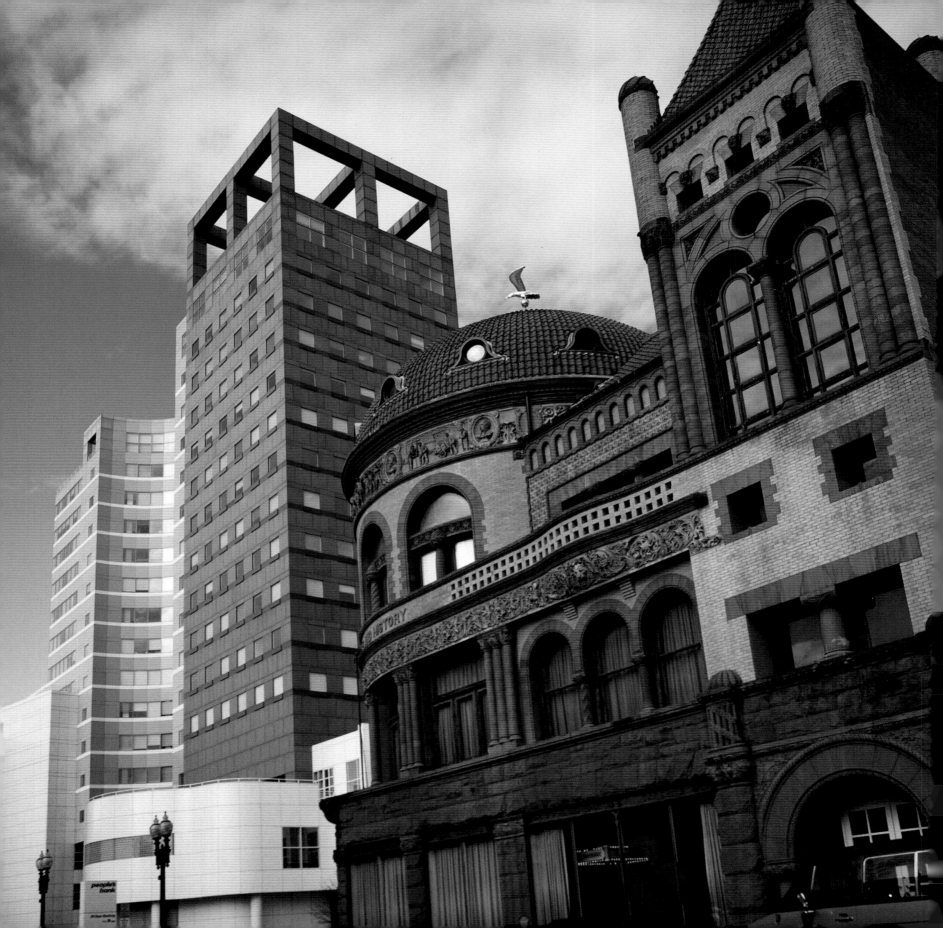

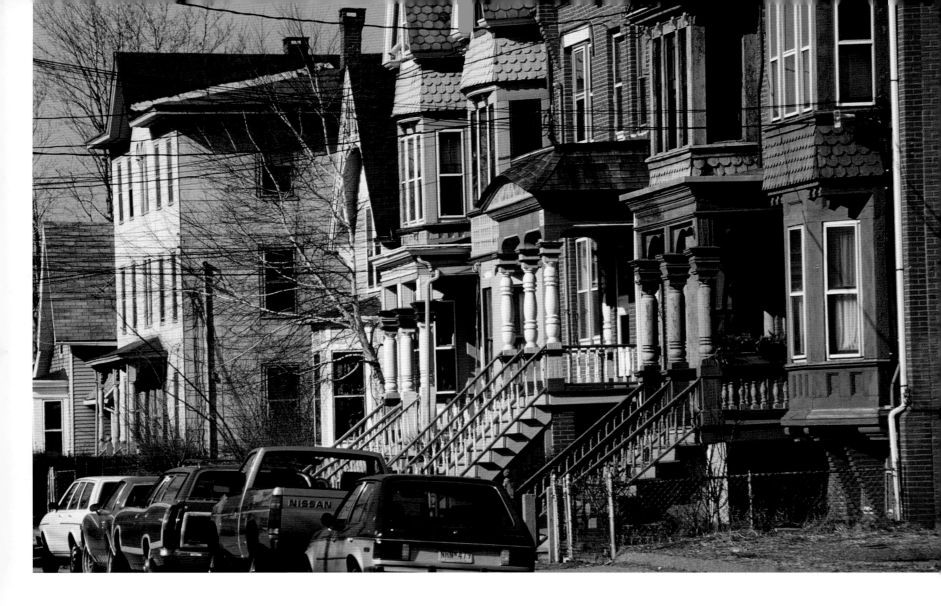

Bridgeport is the state's most populous city. It became industrialized in the 19th and 20th centuries, and by 1930 was home to 500 factories. Bridgeport later experienced an industrial decline, but many of its fine Victorian homes have been preserved.

OPPOSITE PAGE: The Barnum Museum in Bridgeport opened in 1893 to preserve the city's industrial and social history. The facade features beautiful relief panels, and the interior houses thousands of local treasures.

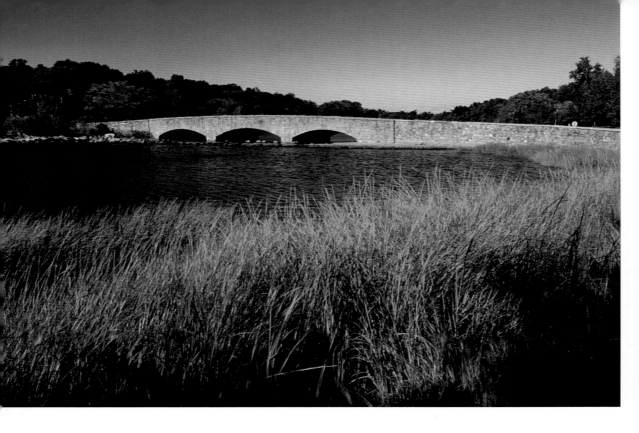

ABOVE: A grist mill and other businesses once stood at the landing near Darien, in Fairfield County. The graceful Rings End Bridge was the third crossing to span the waters here. Although the center of town has moved, the stone structure stands as a reminder of an earlier time.

RIGHT: In the 17th century, Fairfield was the site of confrontations between Native Americans and English settlers. The city was burned during the American Revolution and didn't fully recover for many years. Fairfield now ranks as one of the most affluent places in the country.

FOLLOWING PAGE: The Hartford skyline is seen rising from the banks of the beautiful Connecticut River. The state capital was founded in 1636 by the Reverend Thomas Hooker and a group of 100 people from the Massachusetts Bay Colony. Hartford is home to several respected educational institutions and is known as the insurance capital of the world.

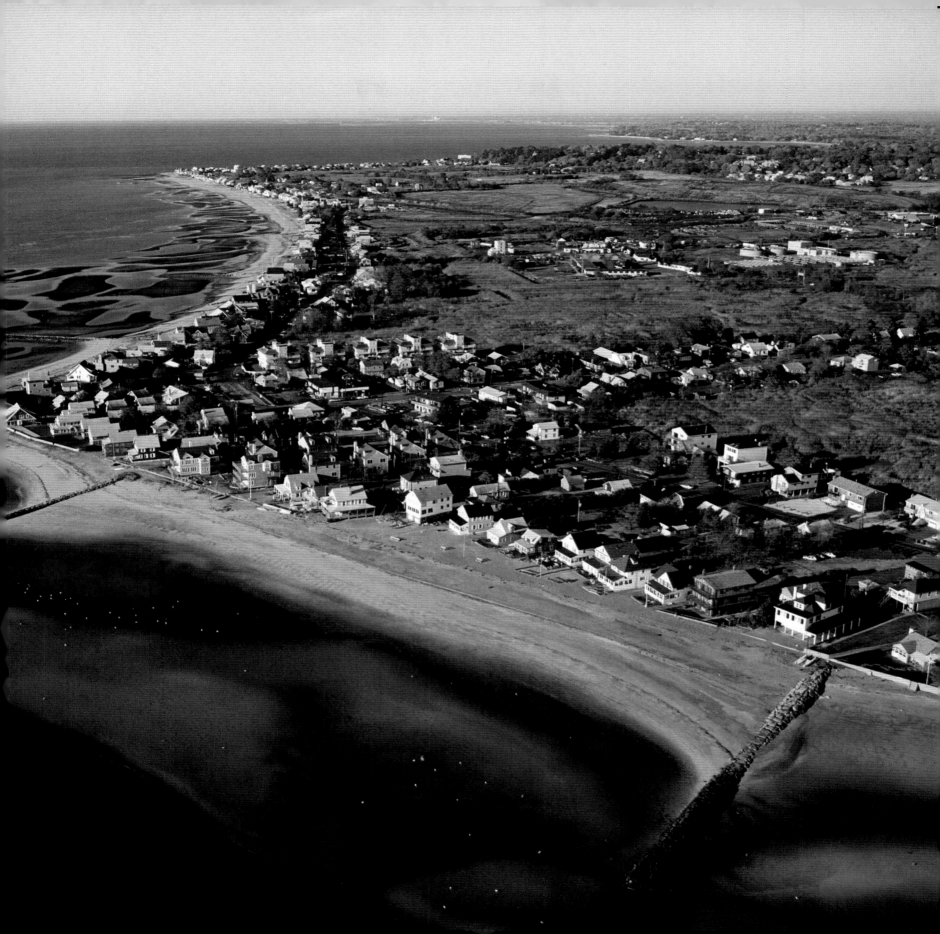

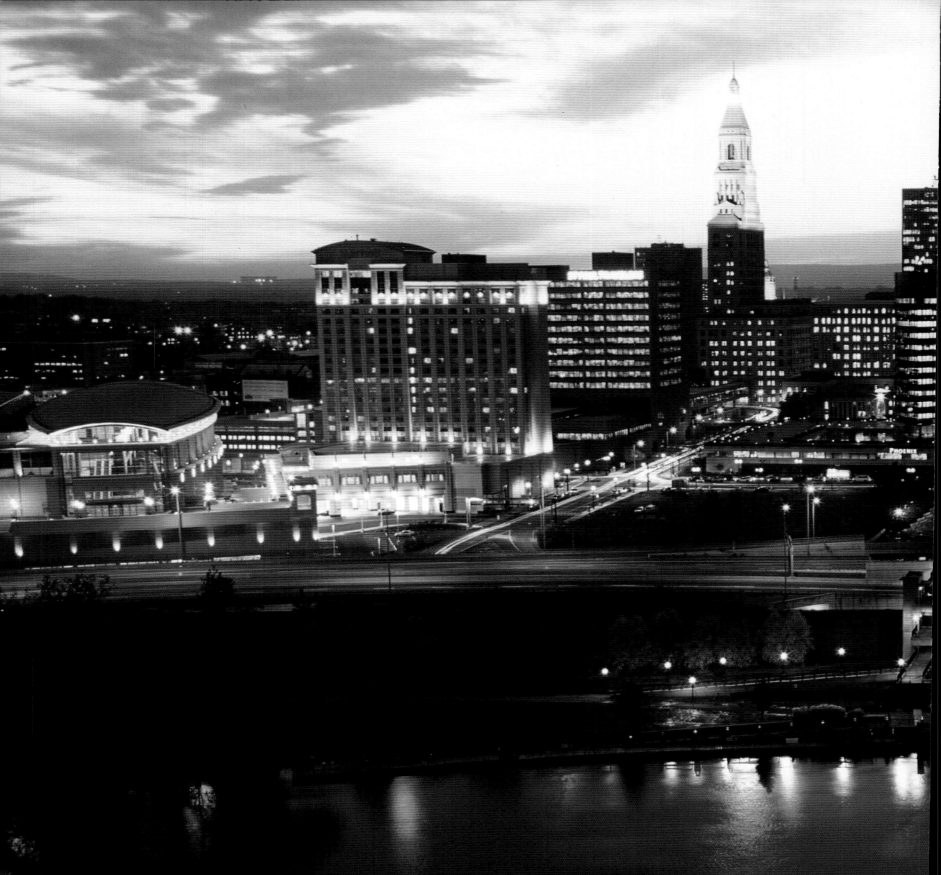

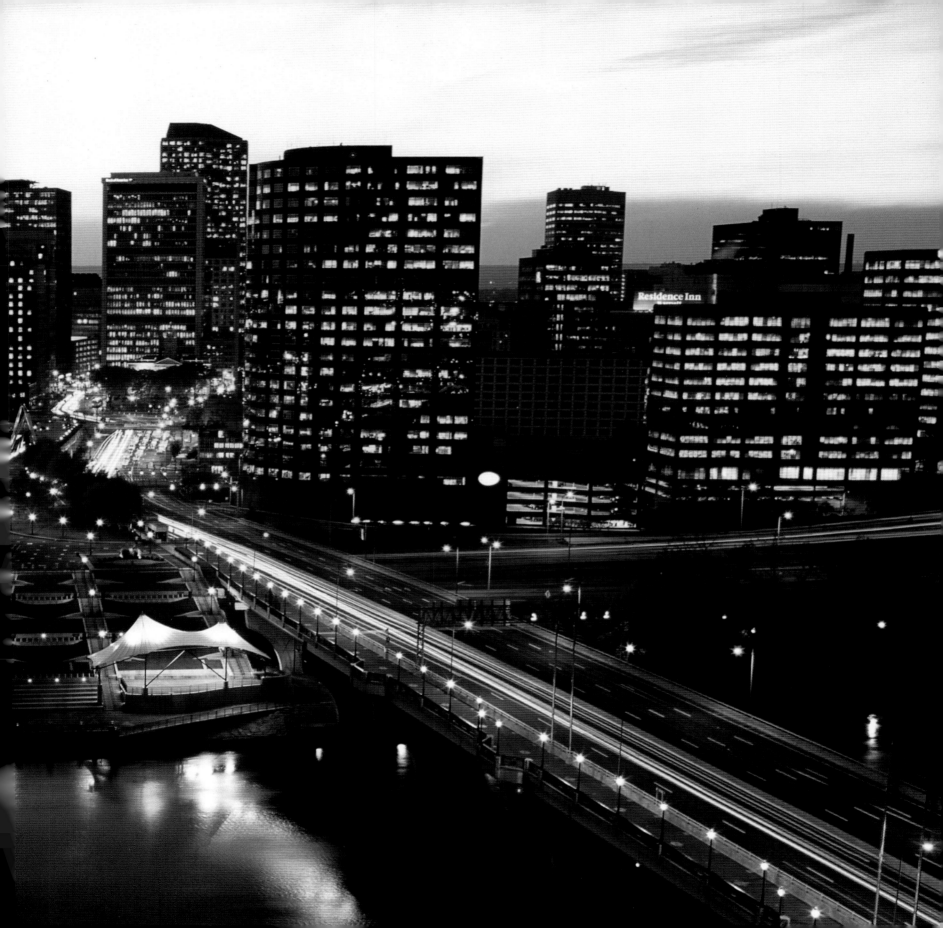

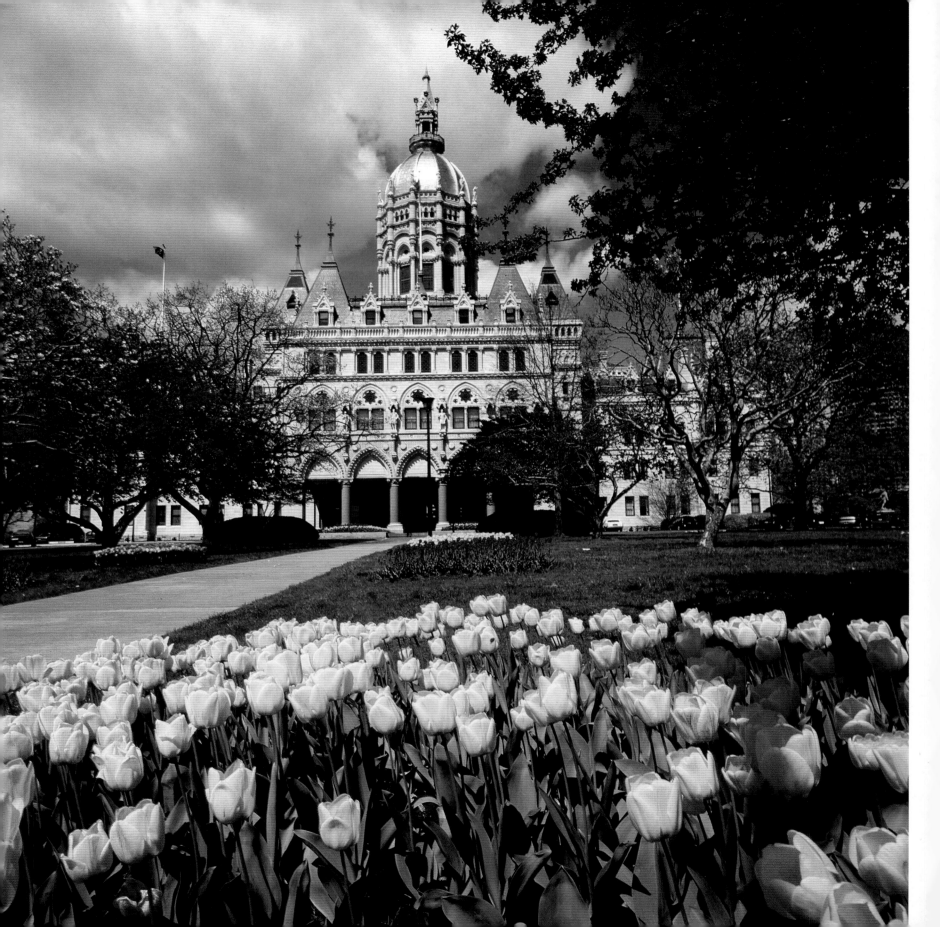

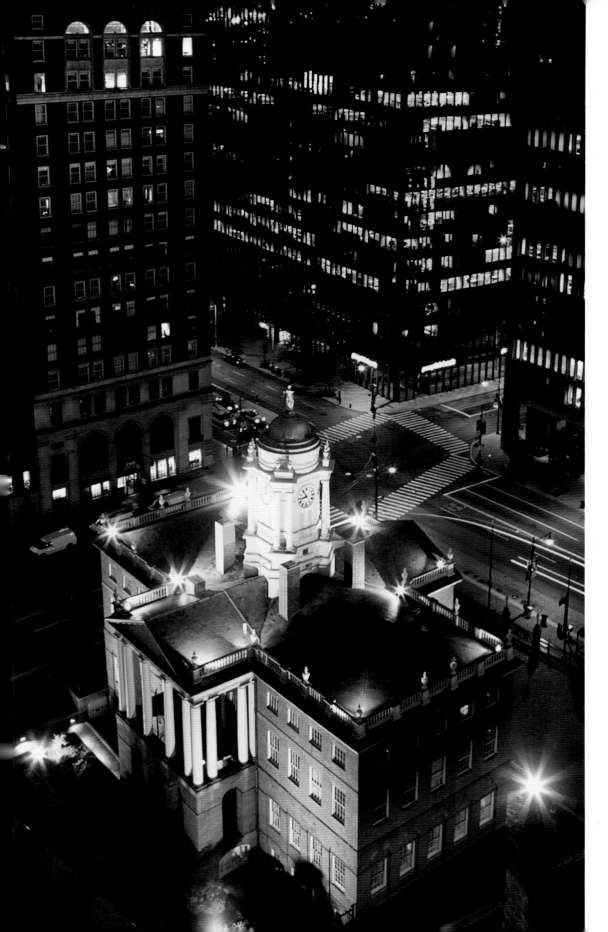

The Old State House in Hartford, seen here surrounded by modern high-rise buildings, was designed by Charles Bulfinch and completed in 1796. It is one of the best surviving examples of Federal architecture in America, with a graceful center hall and an ornate grand staircase.

OPPOSITE PAGE: Hartford's spectacular State Capitol is constructed of marble and granite and features a stunning gold-leaf dome. Its interior is known for its carved oak woodwork and stained-glass windows. The Capitol, which is located south of Bushnell Park, was designed by Richard Upjohn and completed in 1878.

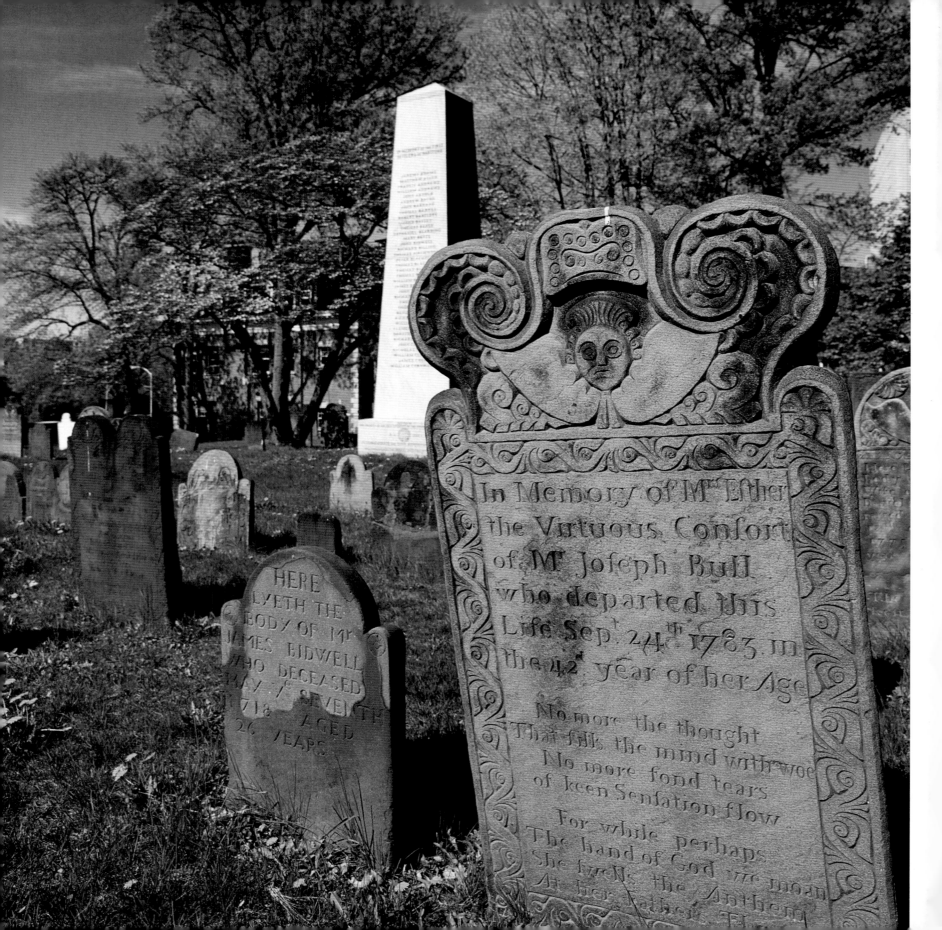

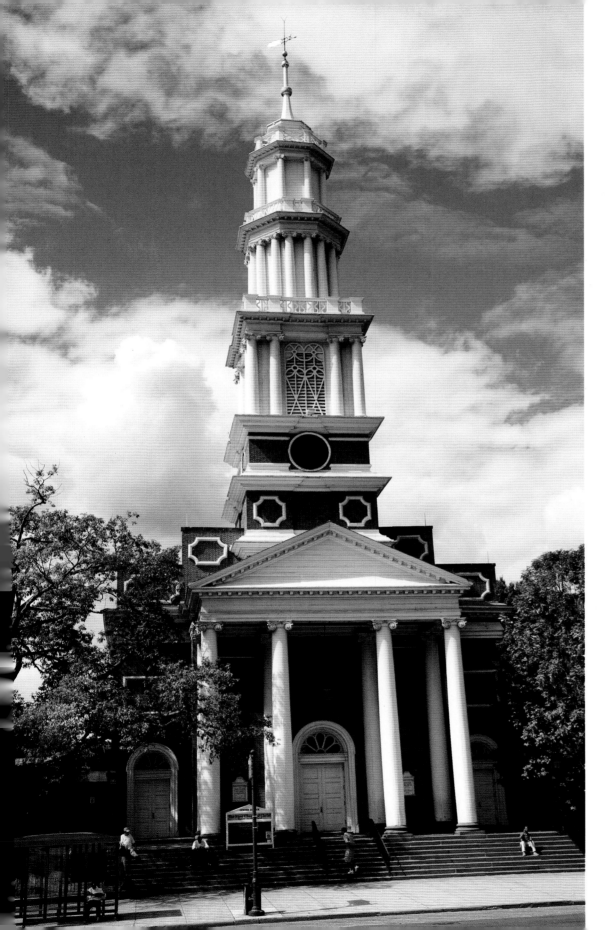

The First Church of Christ in Hartford is known as Center Church. Completed in 1807 at a cost of $32,000, it features numerous treasures, including five stained-glass windows designed by Louis Comfort Tiffany.

OPPOSITE PAGE: The Ancient Burial Ground next to Center Church contains 415 headstones dating back to 1648. Until the early 19th century, it was Hartford's only cemetery, so everyone who died in town — from slaves to Hartford's founder — was interred here. Some 6,000 people were buried here, but most of the monuments are now lost.

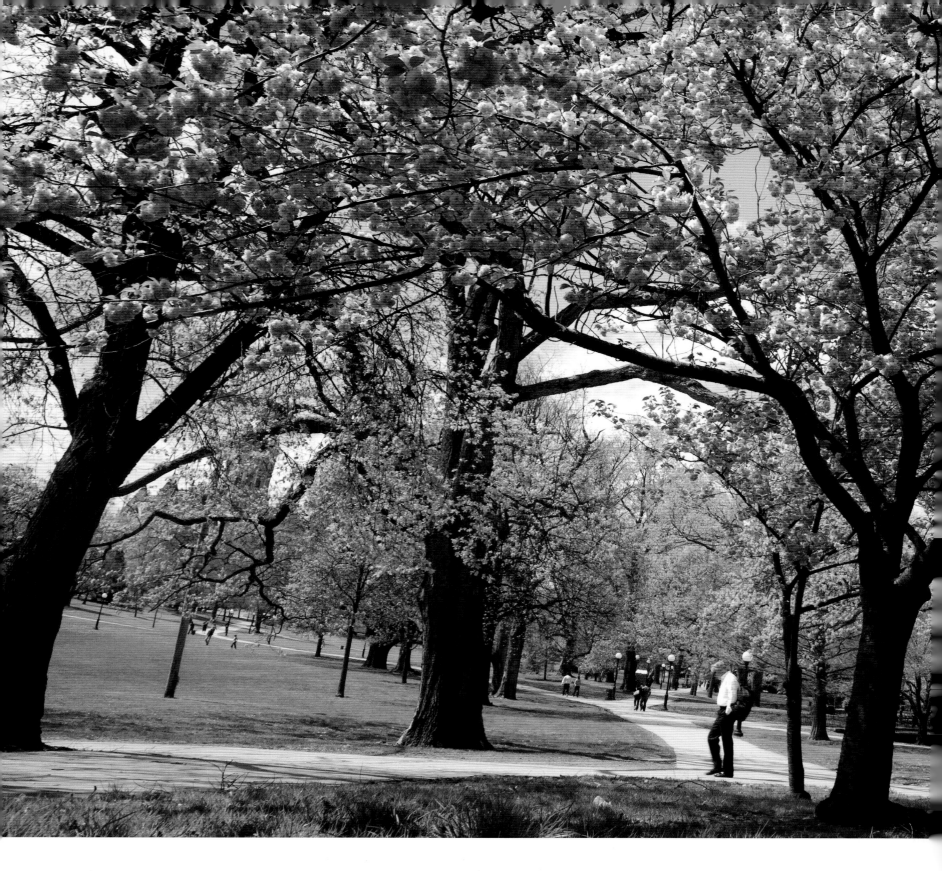

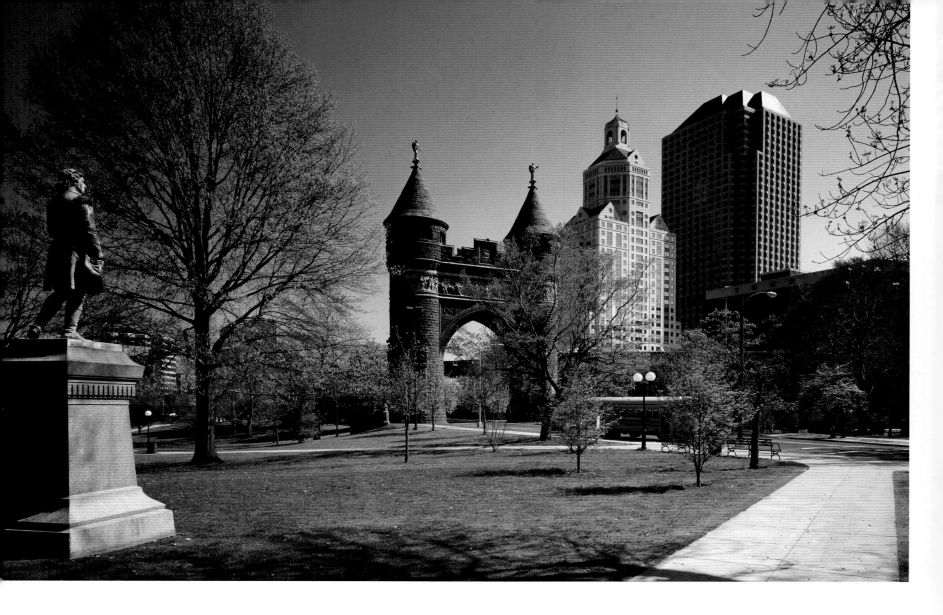

The 40-acre Bushnell Park is known for its 1914 carousel and the Soldiers and Sailors Monument Arch, seen here, commemorating those who served in the American Civil War. The Gothic brownstone arch was designed by George Keller and unveiled in 1886.

PREVIOUS PAGE: More than 100 varieties of trees shade visitors to Bushnell Park, designed by the famous American landscape architect Frederick Law Olmsted. Bushnell was the first municipal park in America to be conceived, built and paid for by citizens through a popular vote.

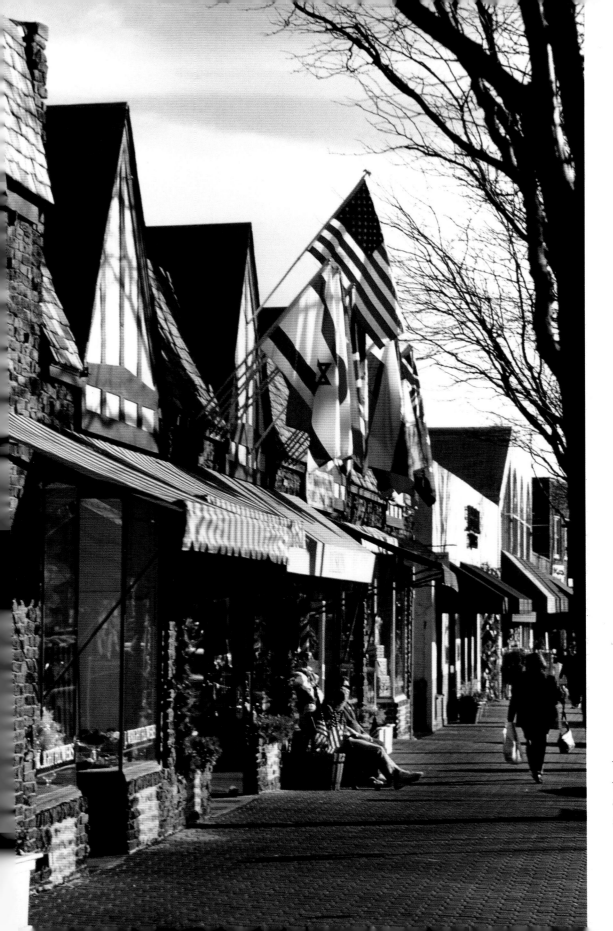

West Hartford has many charming streets with small shops and restaurants. The community is well known for its excellent schools and quality of life.

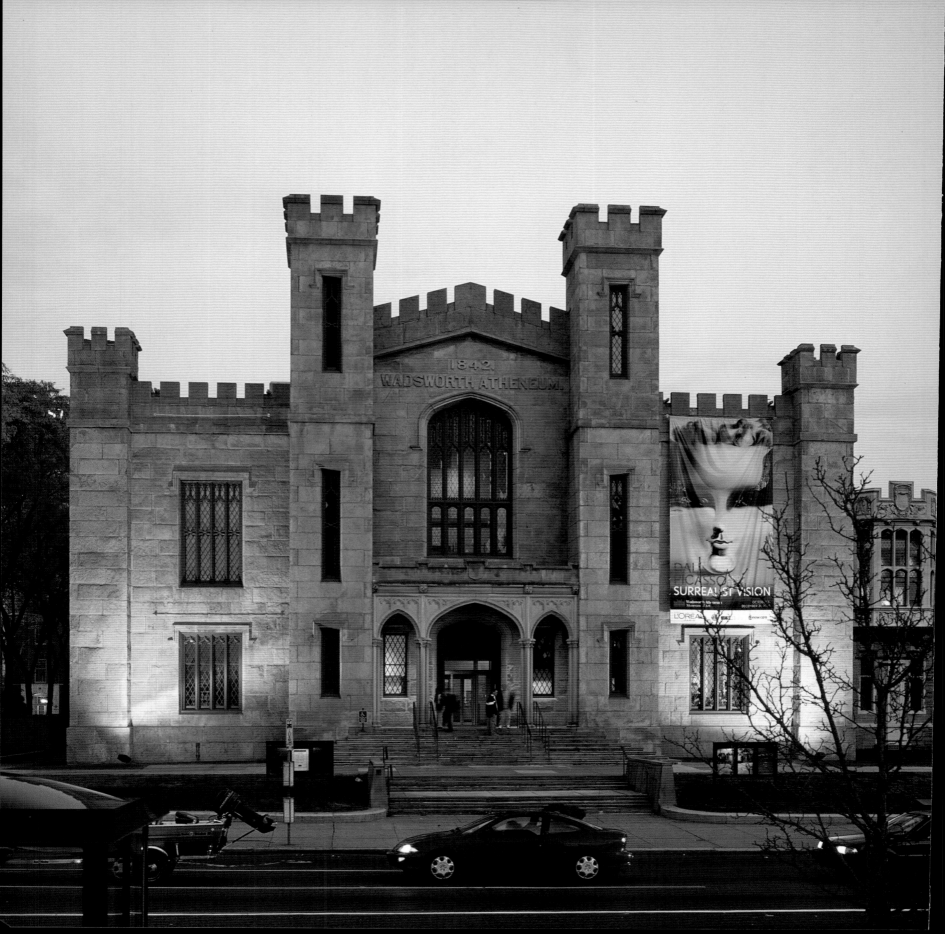

OPPOSITE PAGE: Wadsworth Atheneum is the oldest continually operating public art museum in the country. The Wadsworth, as it is popularly called, was established in 1842 by Daniel Wadsworth, Hartford's most prominent philanthropist and patron of the arts, who donated both the lot and many of the works in the collection.

More than 45,000 works of art fill Wadsworth Atheneum. The collection is known for its Renaissance, Baroque and Impressionist pieces and also boasts a strong collection of American paintings, including works by Thomas Cole and Frederic Church.

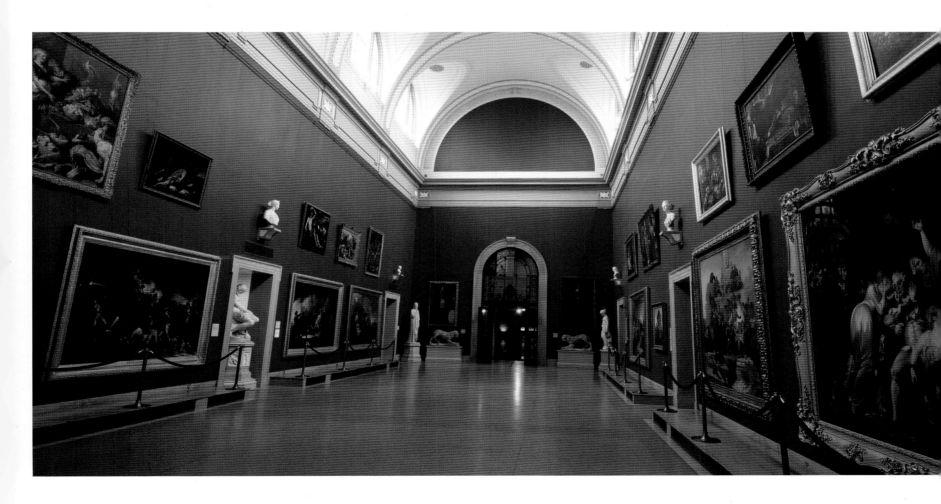

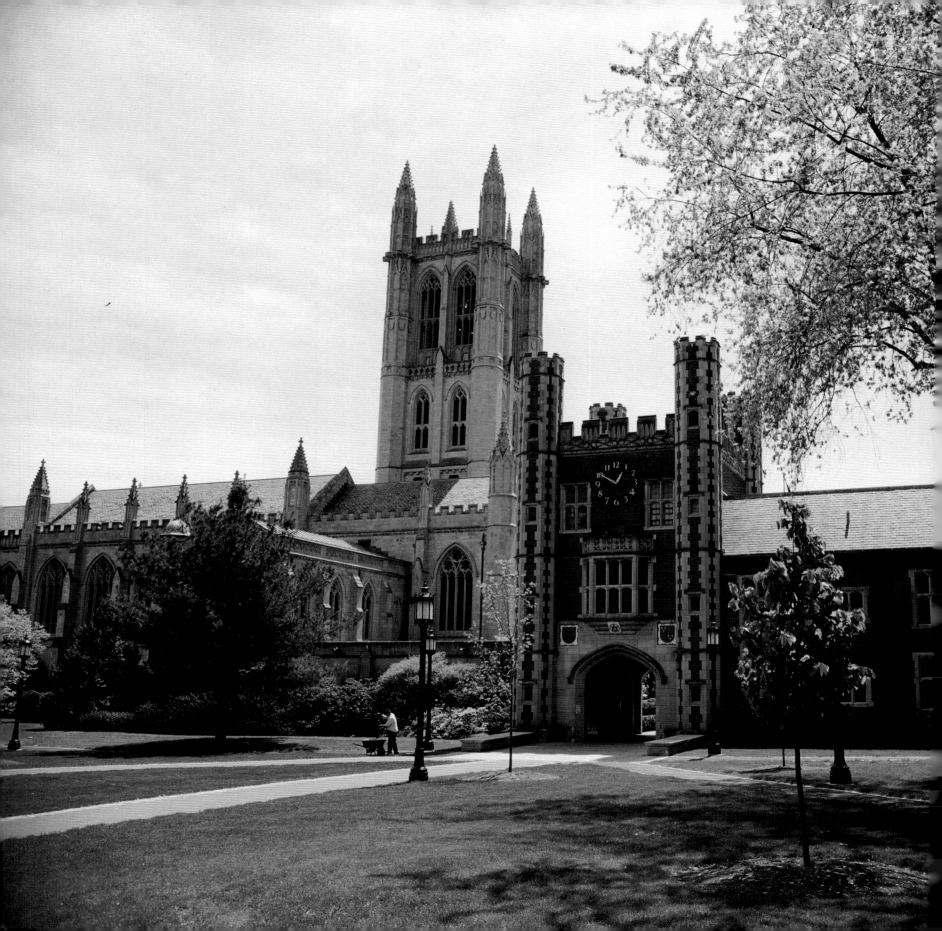

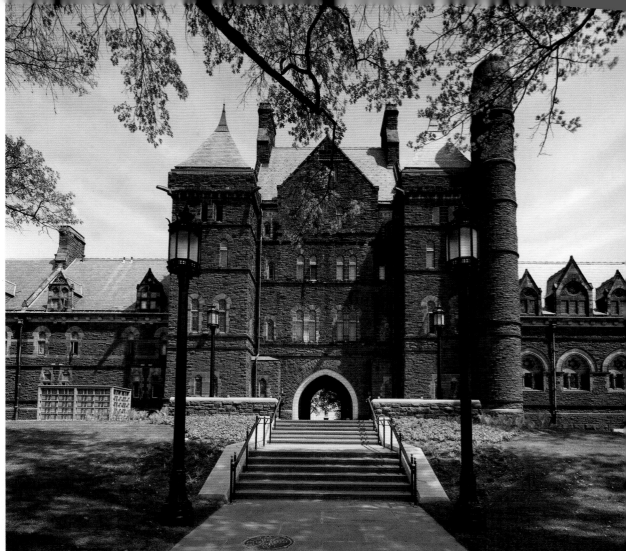

ABOVE: Hartford's Trinity College is the second college founded in the state. The school is known for its rigorous curriculum, small class sizes and tight-knit community.

LEFT: Trinity is a private liberal arts school founded in 1823. The original campus was sold in 1872 as the site of the new state Capitol, and Trinity moved to its present location. The imposing Gothic chapel was completed in 1932.

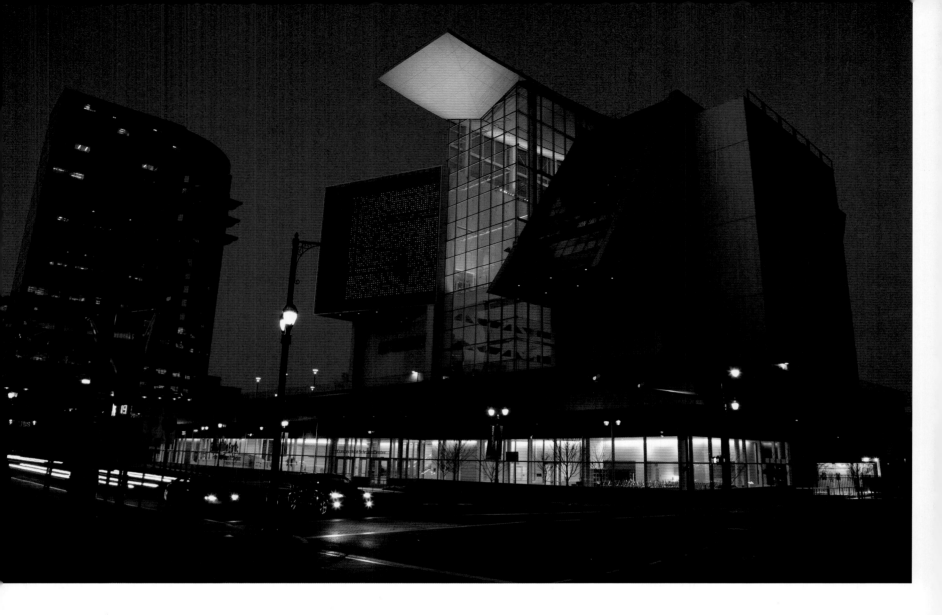

The striking Connecticut Science Center in Hartford features 150 hands-on exhibits on such fascinating topics as robotics, space, sports and health. More than 1.5 million visitors have flocked to the center since it opened in 2009.

OPPOSITE PAGE: In the forefront of this aerial view of Hartford stands the Travelers Tower, completed in 1919, which towers over the old Center Church.

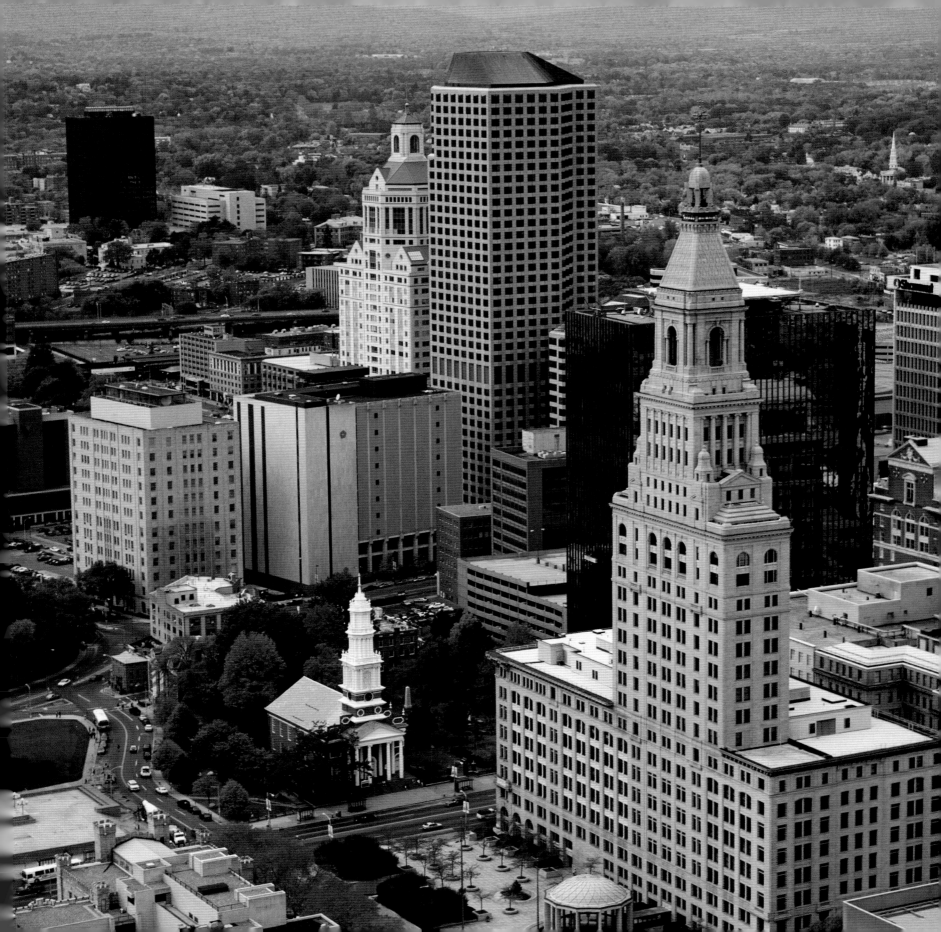

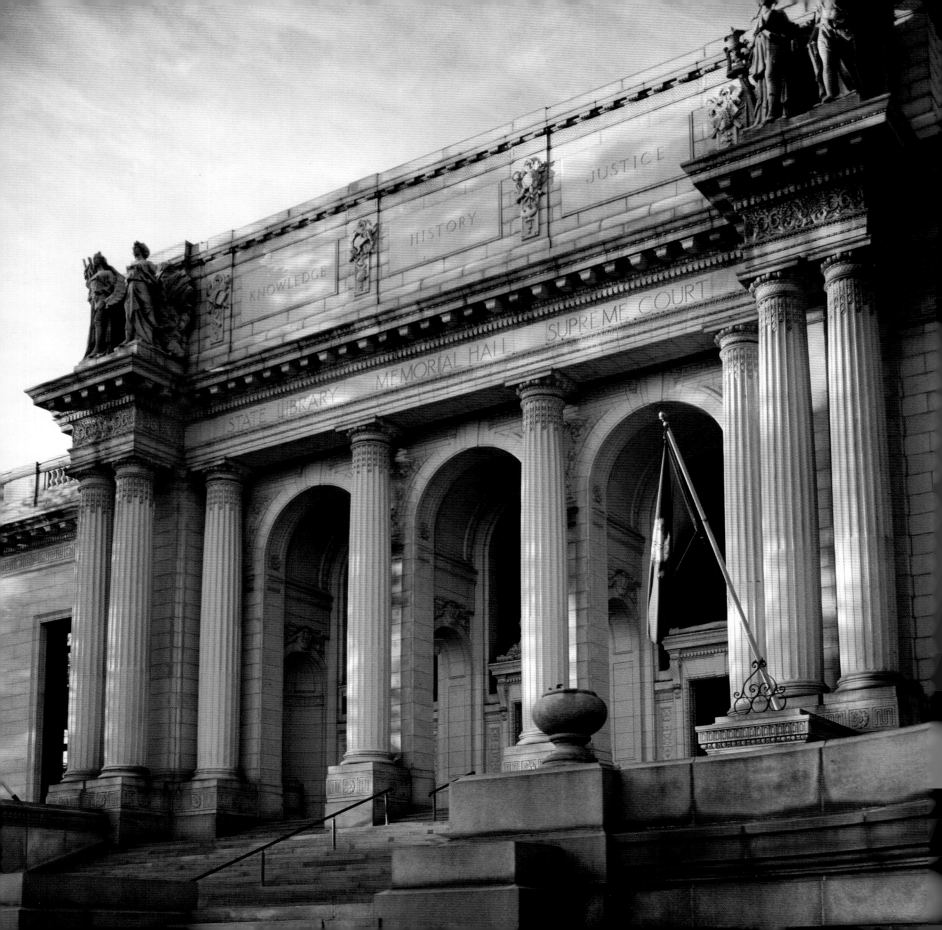

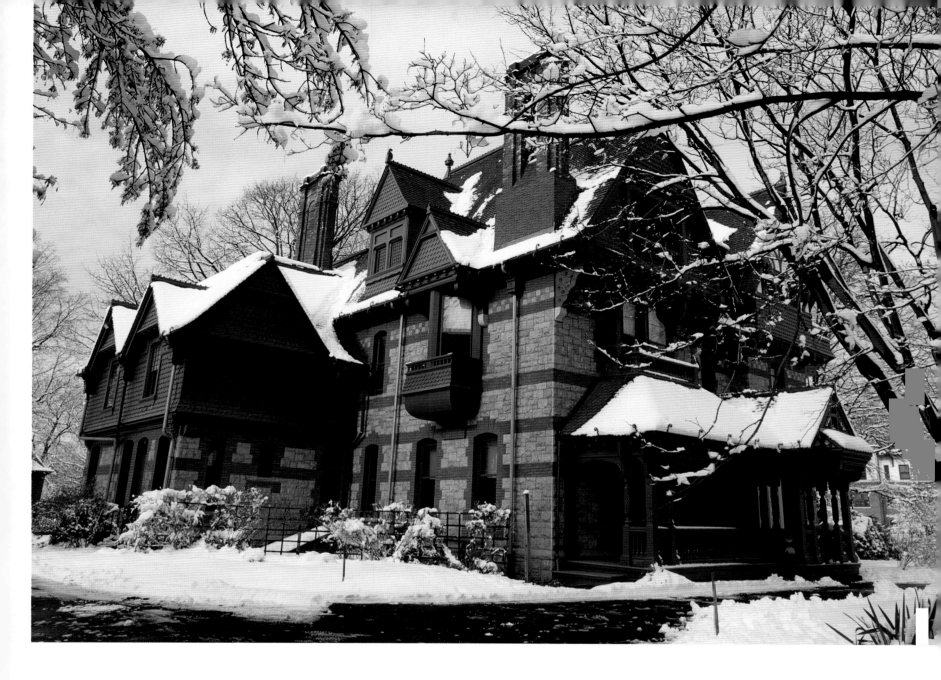

Hartford's Katharine Seymour Day House, now the home of the Stowe Center Research Library, was designed in 1884 and restored in 2002. The rooms are filled with elaborate carvings and furniture. Katharine Seymour Day was an activist and the grandniece of Harriet Beecher Stowe.

OPPOSITE PAGE: The Connecticut State Library and Supreme Court Building, on Hartford's Capitol Avenue, was celebrated as one of the most beautiful buildings of its kind in New England when it opened in 1910. Four 10-foot-high statues adorn the pillars to the main entrance, and the interior boasts the extensive use of marble, stained glass and woodwork.

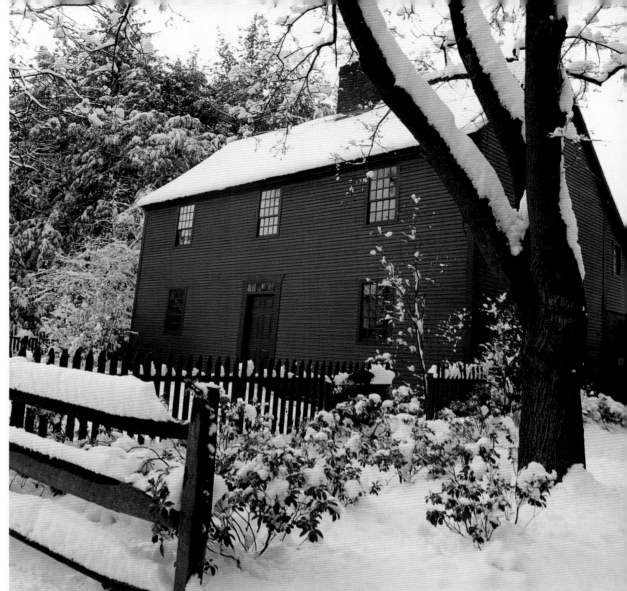

ABOVE: The Noah Webster House in West Hartford is the restored 13th-century home of its namesake, the creator of the first American dictionary. The home and museum attract 10,000 schoolchildren every year, as well as thousands of other visitors from all over the country and abroad.

LEFT: A statue of Noah Webster marks Blue Back Square in West Hartford. Webster was born in West Hartford in 1758, distinguishing himself from an early age and later at Yale University. He began work as a teacher, and in 1783 produced an English textbook nicknamed the "Blue-Backed Speller," which was a standard work used in schools over the next century. The first edition of his dictionary appeared in 1806.

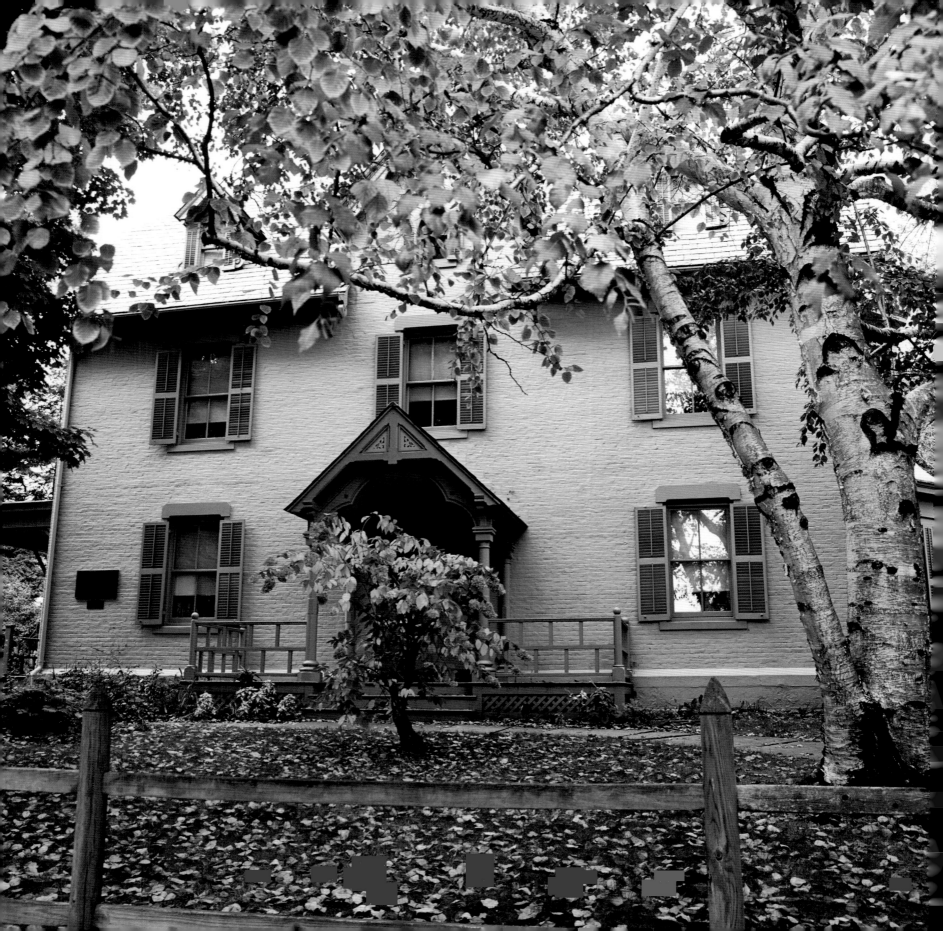

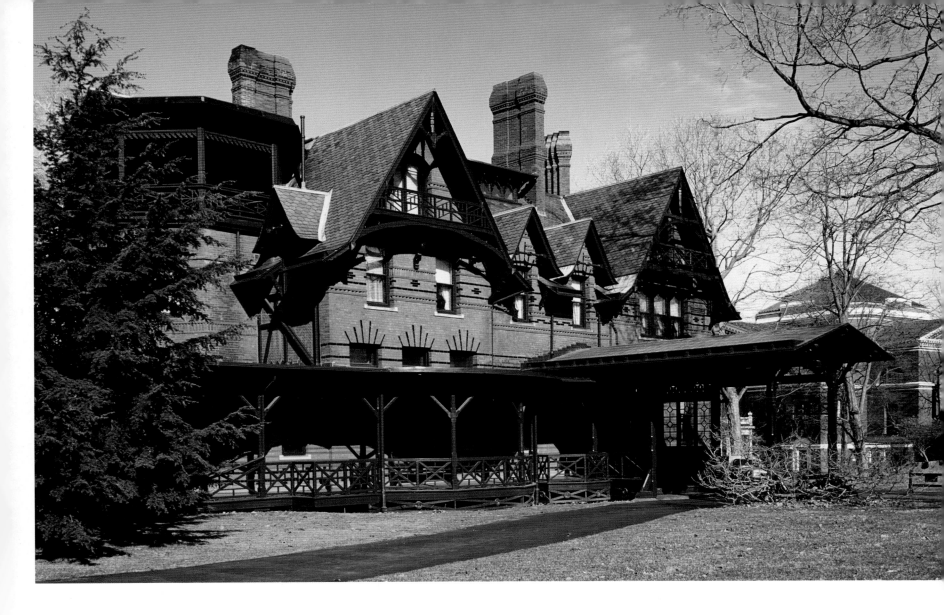

In the second half of the 19th century, Nook Farm, a neighborhood on the edge of Hartford, was home to a number of important Americans. From 1874 to 1891, humorist and author Mark Twain lived in this gabled and turreted masterpiece. Now a museum, it draws fans because of its architecture and its association with one of the best-loved American writers of the 19th century.

OPPOSITE PAGE: Harriet Beecher Stowe, the internationally renowned author of *Uncle Tom's Cabin*, lived in the neighborhood of Nook Farm. Her home is now the Harriet Beecher Stowe Center, dedicated to the author and her influential work.

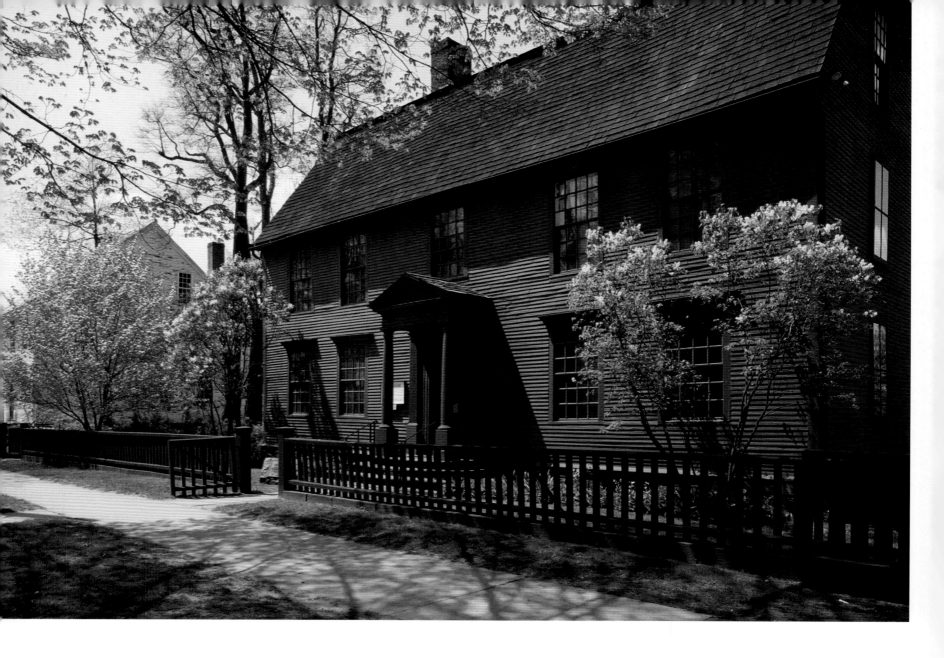

The Webb-Deane Stevens Museum in Wethersfield consists of four remarkable 18th-century houses that have been meticulously restored to bring the past alive for visitors. This is the Joseph Webb House; it was built in 1752 and served as George Washington's headquarters in May 1781.

OPPOSITE PAGE: Comstock Ferre Seed Co., founded in 1820 in Wethersfield, is the oldest continually operating seed company in America. The picturesque structure is surrounded by dozens of historic homes and well-manicured gardens in this affluent Hartford suburb.

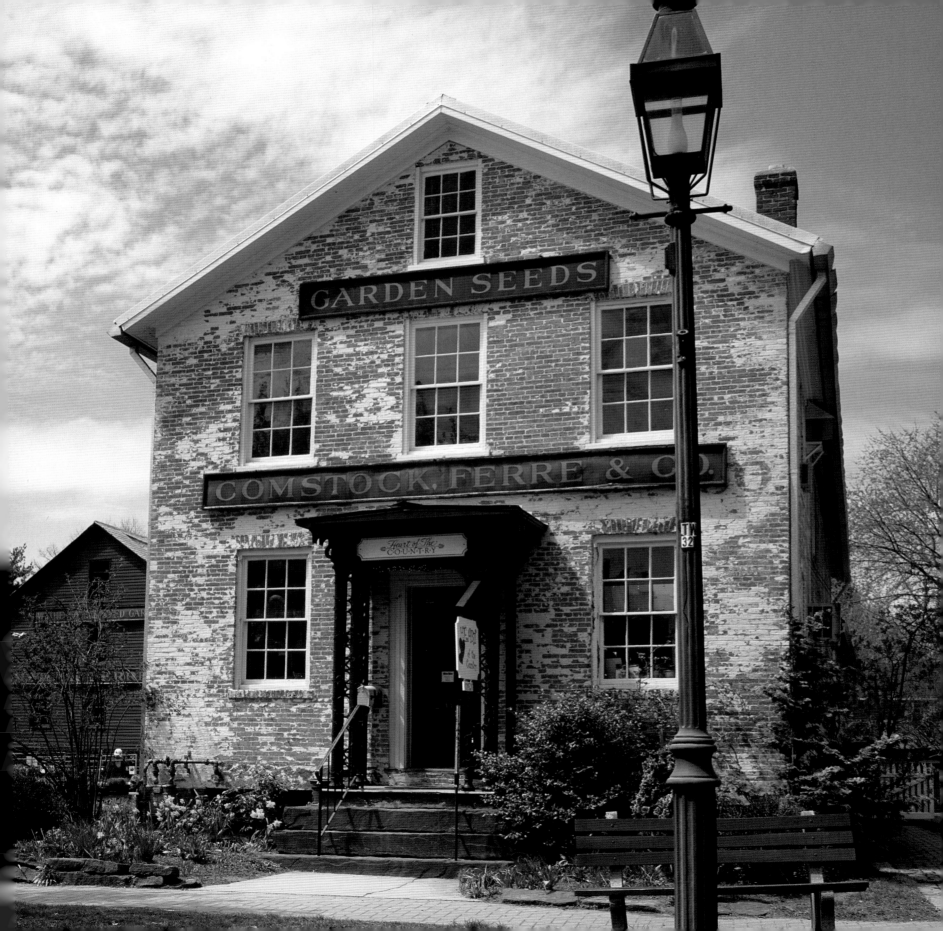

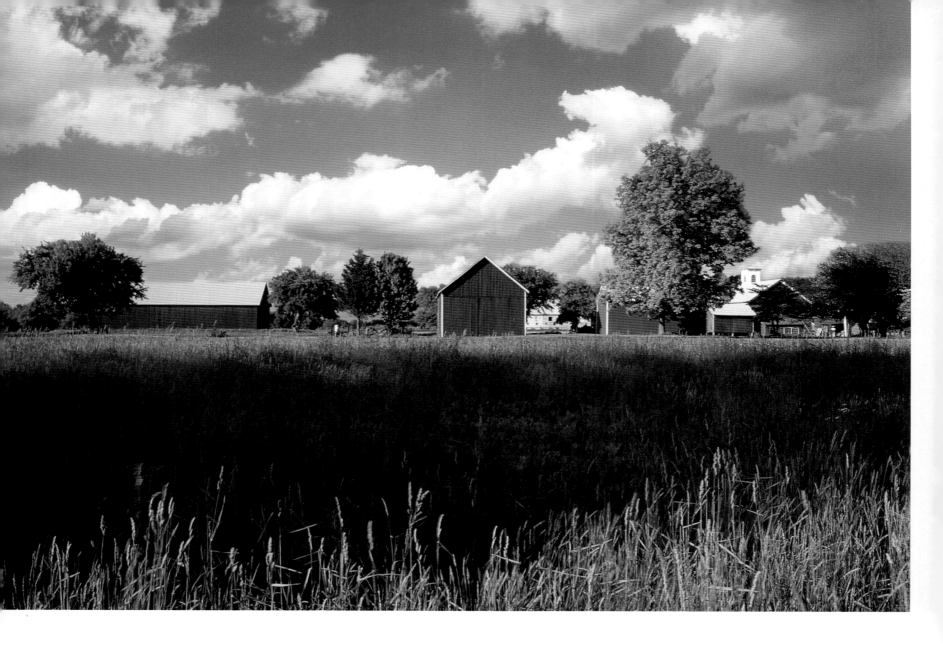

This quintessential New England farm is found in Glastonbury, an affluent town in Hartford County, but its likes can be seen all over Connecticut. The state attracts tourists for its picture-postcard communities.

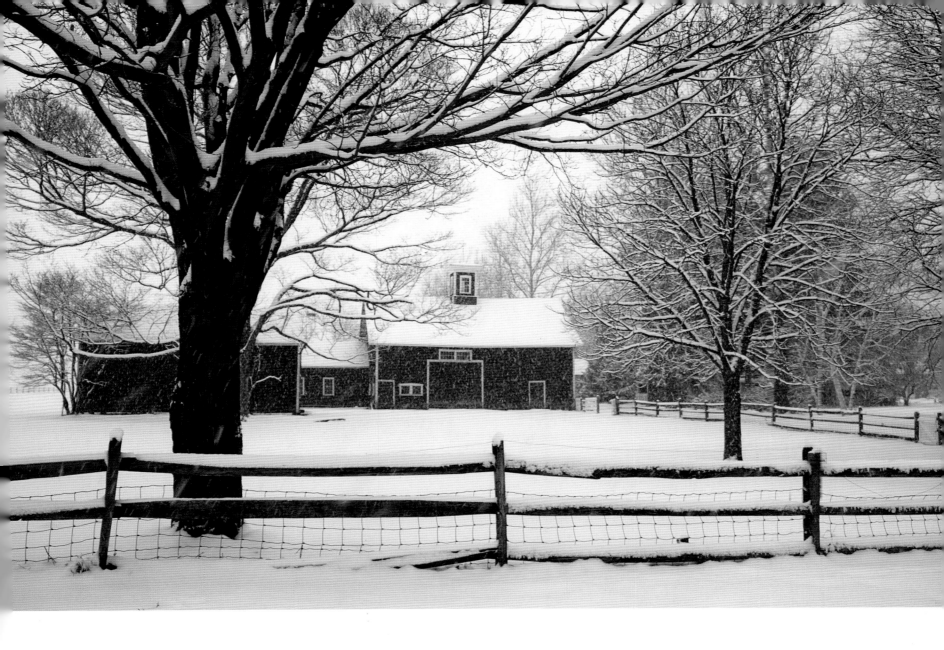

This East Windsor farm is typical of countless such settings in Connecticut, charming in both summer and winter. Greenhouse and nursery products are the state's leading source of agricultural income, followed by dairy products, eggs and tobacco.

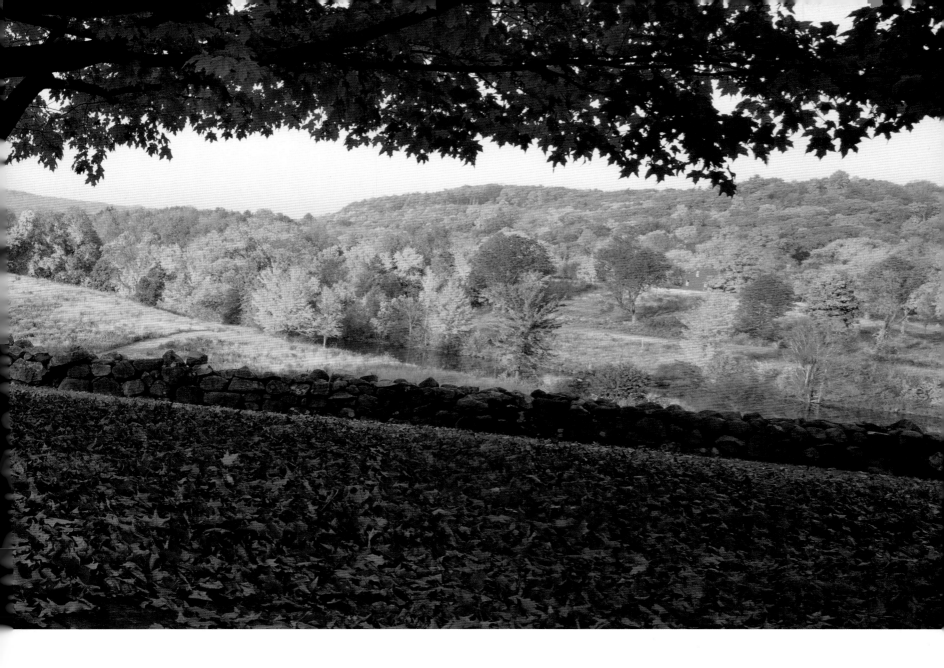

Autumn turns Connecticut's deciduous forests into a riot of color. Many agree that this is the most beautiful time to visit the state.

FOLLOWING PAGE: Residents of Marlborough and places like it across the state treasure their horse farms, historic barns and quiet way of life.

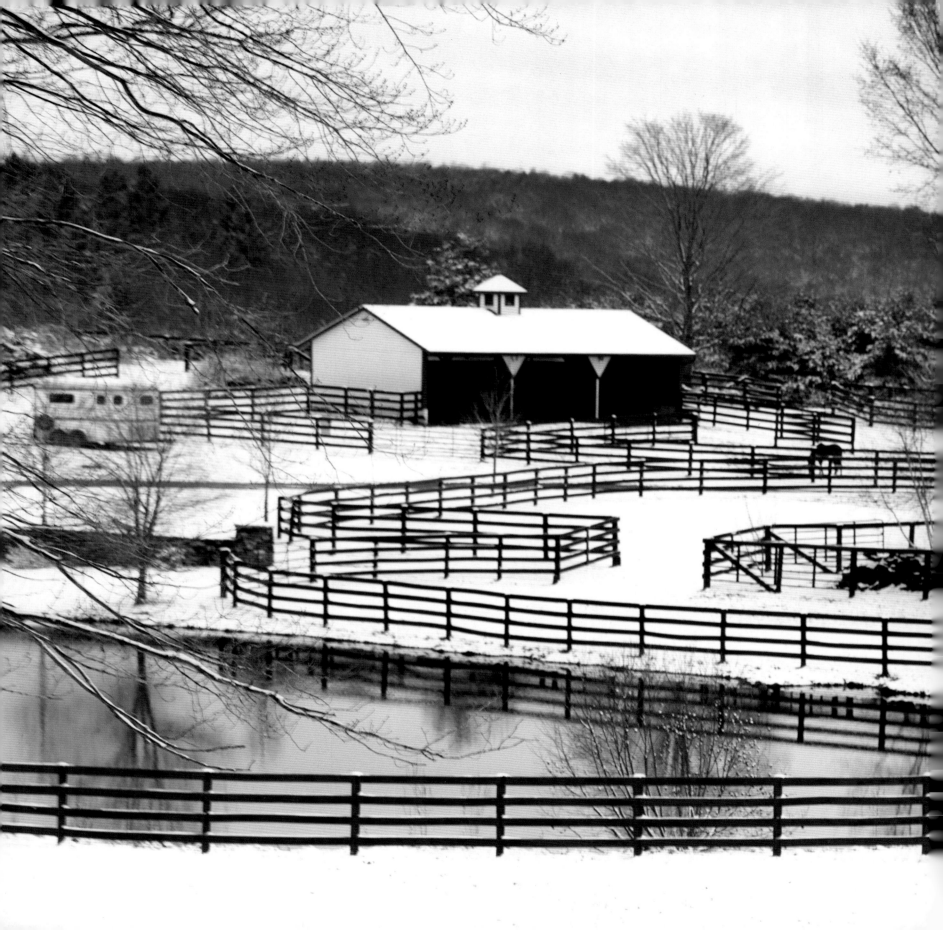

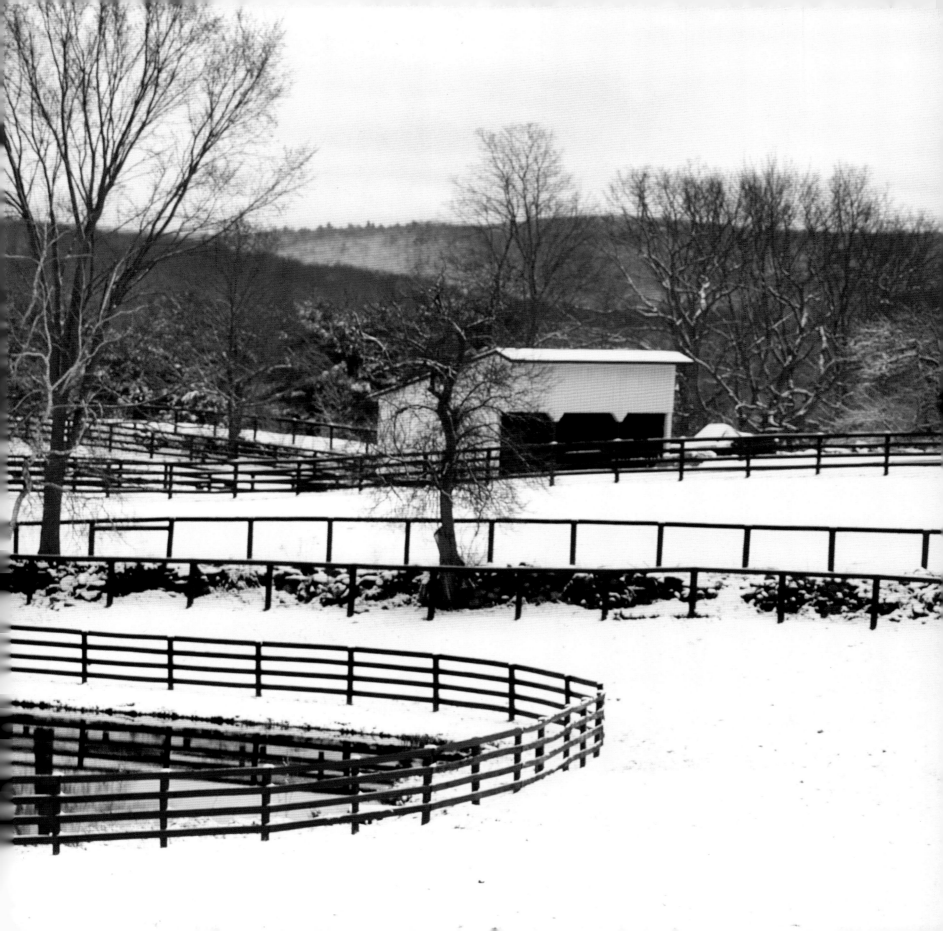

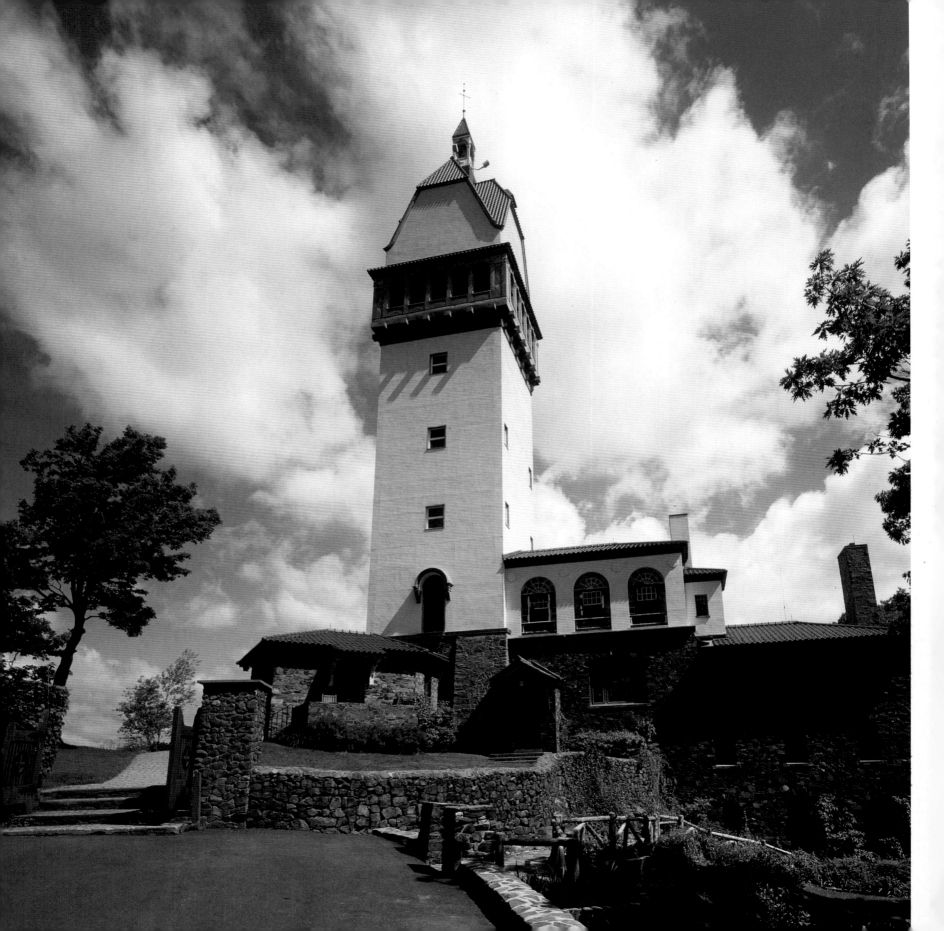

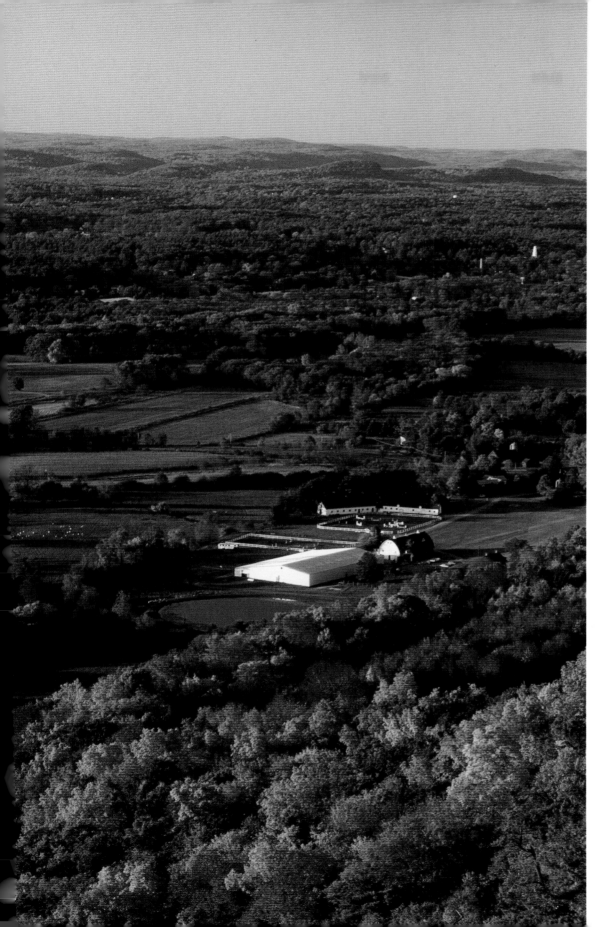

OPPOSITE PAGE: Heublein Tower was built as a summer home in 1914 and modeled after the style of building in the owner's native Bavaria. The structure is now protected within Talcott Mountain State Park. Visitors can survey the surrounding landscape from the top of the 165-foot tower.

Heublein Tower stands atop the highest point of Talcott Mountain, in Simsbury. This beautiful view of fall colors is seen from the observation room at the top of the tower.

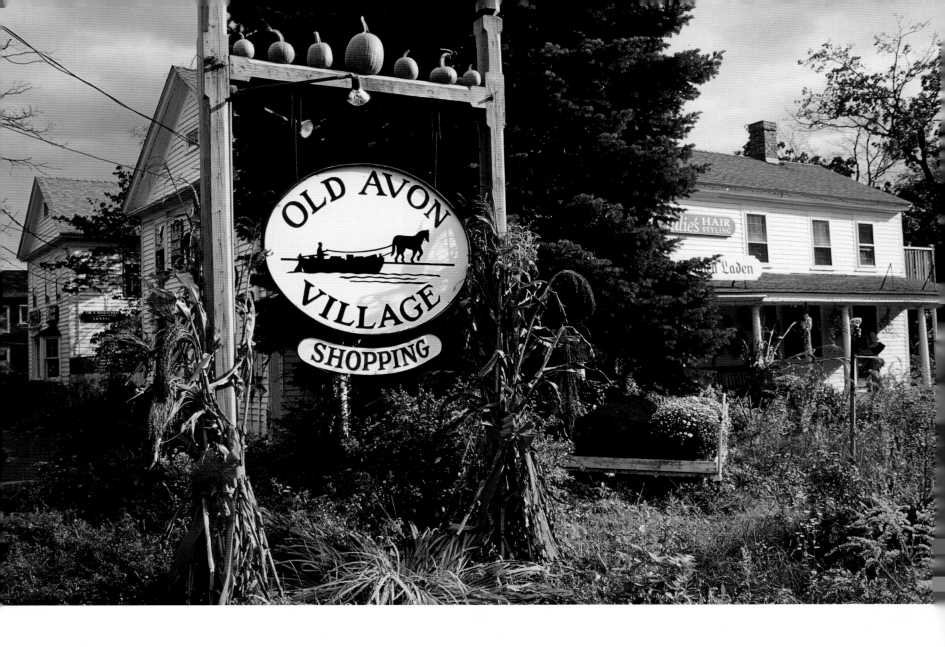

Avon, a picturesque New England village nestled in the Farmington Valley, was settled in 1645. The prosperous community has a population of 17,000 people.

The Phelps-Hatheway House and Garden in Suffield allows visitors to see what life was like for two wealthy 18th-century families. The original structure was built for a Tory sympathizer whose business suffered during the Revolution. The next owner added the wing, remarkable for its fine woodwork and original Paris-made wallpaper.

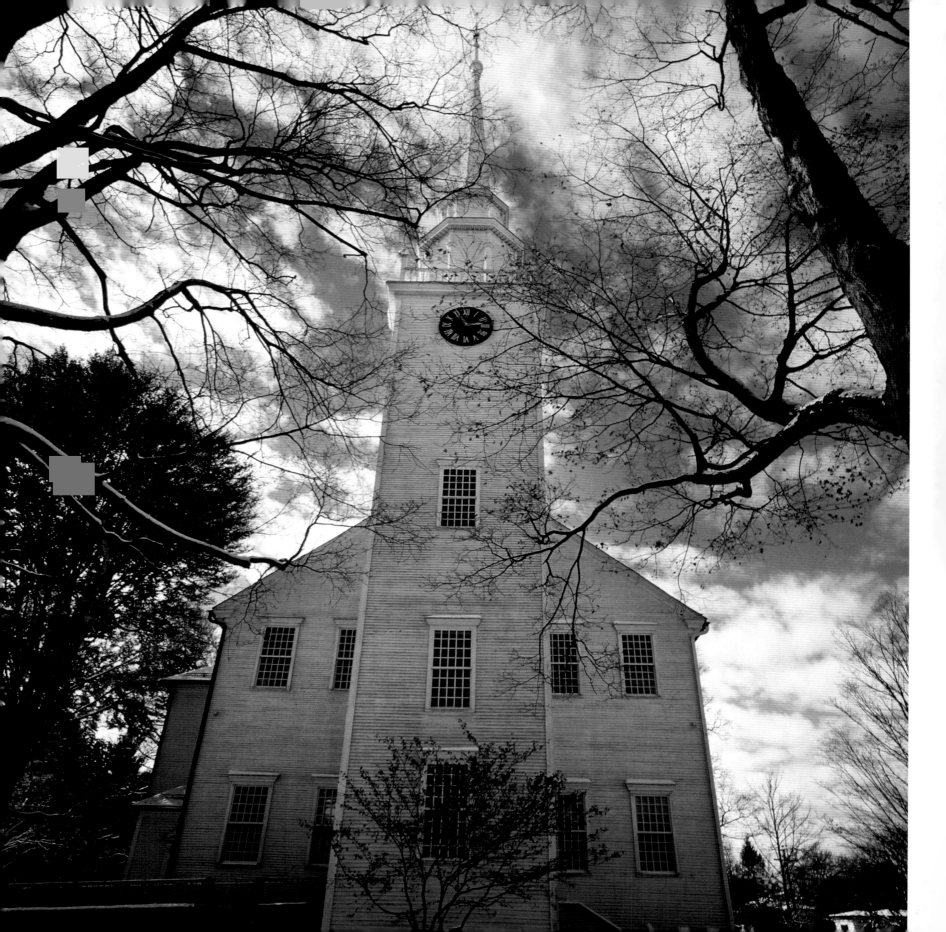

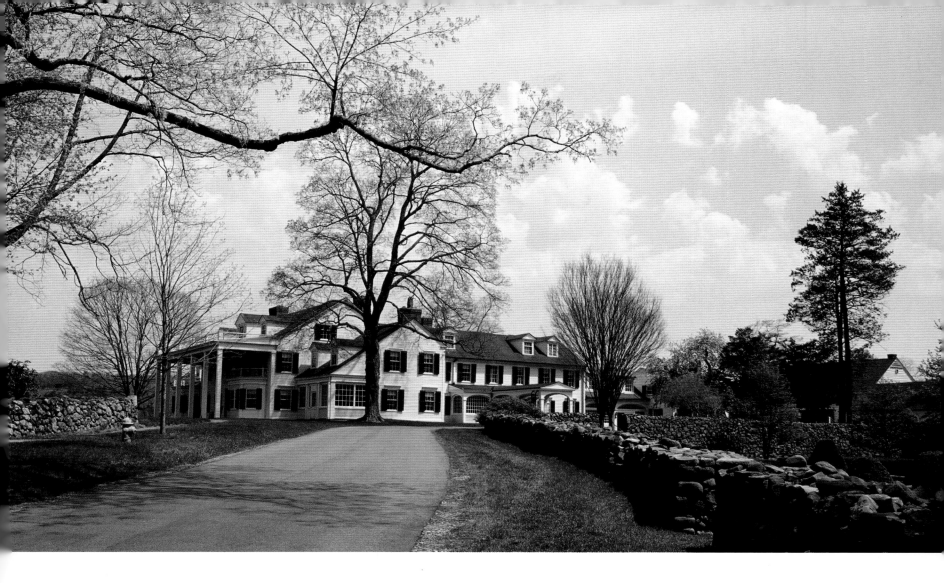

The Hill-Stead Museum in Farmington offers visitors a unique chance to step back into the Edwardian period. Theodate Pope Riddle, one of America's first female architects, designed this home for her parents. Her will stipulated that Hill-Stead become a museum "for the benefit and enjoyment of the public," and that nothing could be changed or moved after her death.

OPPOSITE PAGE: The First Church of Christ in Farmington was built in 1771 as the third meeting house of a congregation that dates back to 1652. The church is said to have one of the most beautiful steeples in New England. Its parishioners have a long and distinguished history of outreach work.

FOLLOWING PAGE: The stone walls found throughout New England were used both to contain animals and to mark property borders. The golden age for these structures was between 1775 and 1825, when tens of thousands of miles were constructed in Connecticut alone.

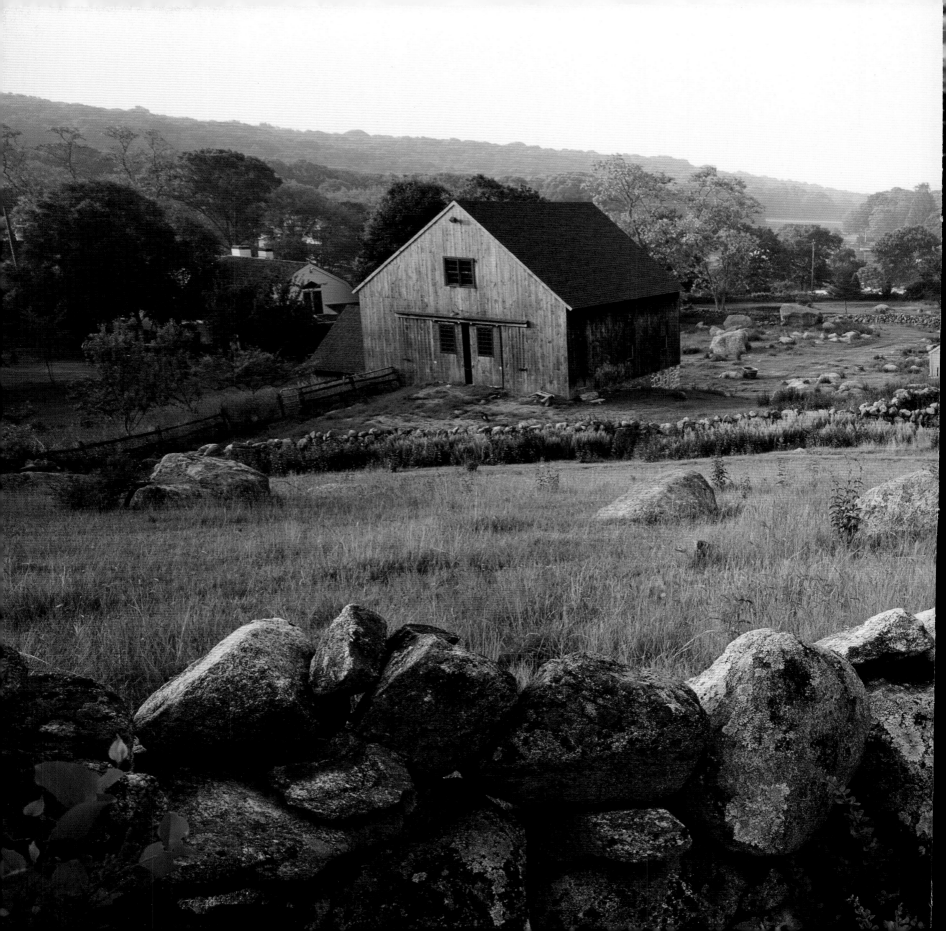

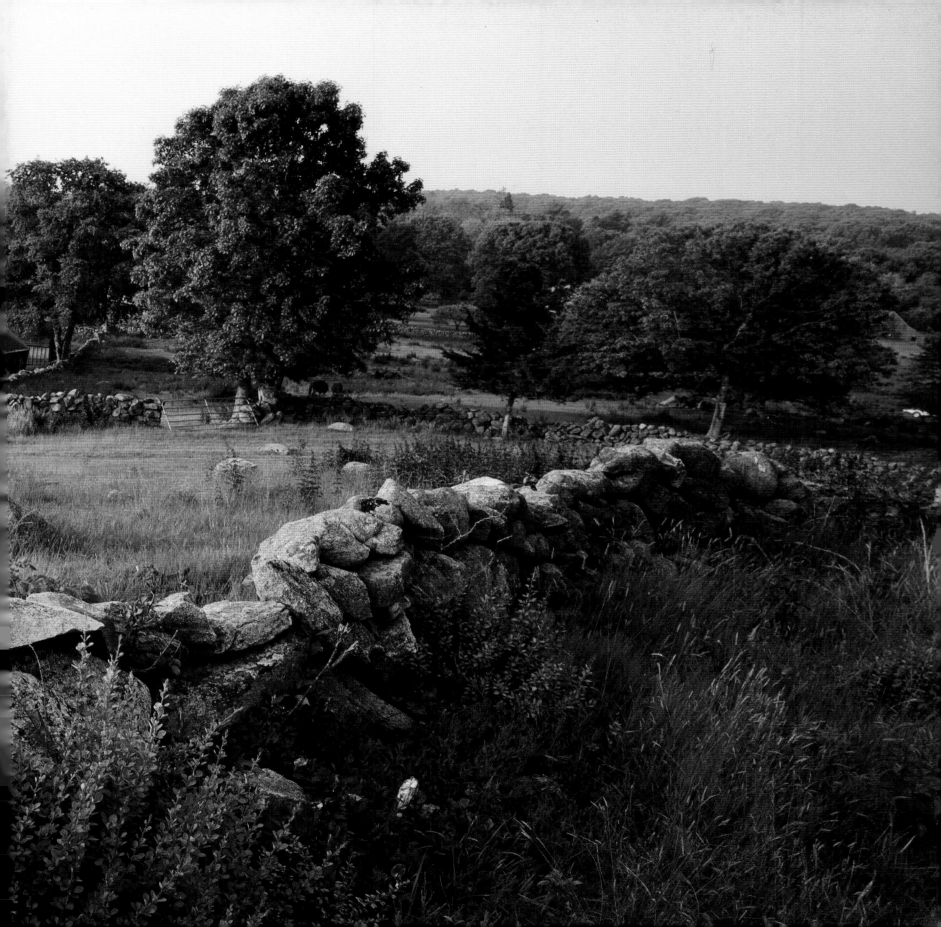